IMAGES
of America

OLD LOUISVILLE

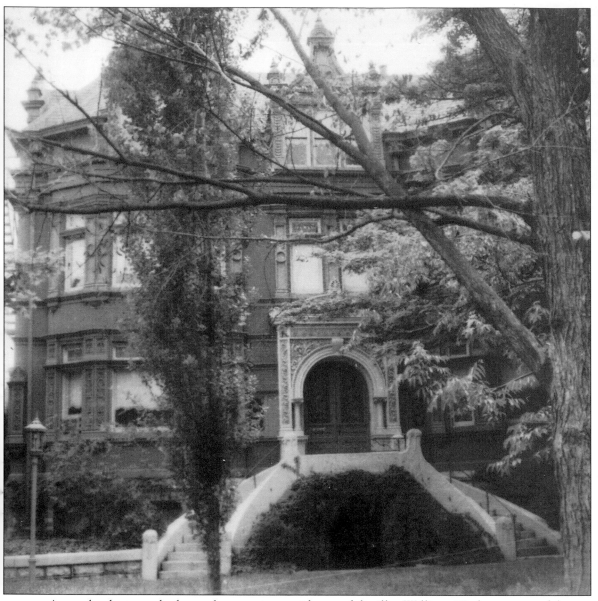

An early photograph shows the one-time residence of distiller William Wathen, a graceful Chateauesque mansion that was one of scores built on the site of Louisville's famed Southern Exposition of the 1880s. Housed in what was then touted as the world's largest wooden structure, the massive exhibit hall of this early world's fair was constructed in a largely unpopulated area known as the Southern Extension. When the structure was dismantled several years later, its footprint would lay the groundwork for Belgravia Court and St. James Court, the residential showcase of today's Old Louisville historic preservation district. (Courtesy of the Conrad-Caldwell House Museum.)

ON THE COVER: A photograph from about 1906 shows the family of William Caldwell as they depart for an outing in their new automobile. In the background stands their stone mansion at 1402 St. James Court, built in the Richardsonian Romanesque style in the 1890s by famed Louisville architect Arthur Loomis. (Courtesy of the Caldwell family.)

IMAGES
of America

OLD LOUISVILLE

David Dominé and Ronald Lew Harris

ARCADIA
PUBLISHING

Published by Arcadia Publishing
Charleston, South Carolina

Printed in the United States of America

Library of Congress Control Number: 2010920125

For all general information contact Arcadia Publishing at:
Telephone 843-853-2070
Fax 843-853-0044
E-mail sales@arcadiapublishing.com
For customer service and orders:
Toll-Free 1-888-313-2665

Visit us on the Internet at www.arcadiapublishing.com

To all those who love Old Louisville and strive to protect it
We are the stewards of a bygone time, the
protectors of an irreplaceable glory.

CONTENTS

ACKNOWLEDGMENTS

The book you hold in your hands largely represents the people's archive.

People like Lois Tash, longtime resident of Old Louisville who saw the razing of not only two Victorian homes her family lived in but also the neighborhood hospital (Norton Infirmary) in which she was born, or Ginny Keen, a lifelong denizen of Second Street who got out her photograph albums in the midst of babysitting four children, to find what she could to help us. Or Ray Morgan, a man who, after falling in love with Old Louisville, purchased the Mengel mansion, then rolled up his sleeves and began a loving restoration. During the course of the work, he found in his basement a series of vintage interior photographs that grace the pages you are about to enjoy. In short, the people of Old Louisville rose up, searched attics, basements, and their memories and aided us in producing this volume. The one large archive that we did use, the excellent collection at the University of Louisville's Eckstrom Library, is an Old Louisville neighbor.

We wish to express our appreciation to the Conrad-Caldwell House Museum, its curator Deb Riall and Peter J. Silva for use of original photographs from the museum's archive. We also owe a debt of gratitude to Margaret Young and the entire Caldwell family for searching multiple residences for photographs made by ancestor Walter Caldwell, a turn-of-the-20th-century amateur photographer on St. James Court. Thanks must also be given to Angela Hagan and the Cabbage Patch Settlement House Archive. Ms. Hagan was one of the first to contact us and offer assistance. David Pearson of Pearson's Funeral Home took the time to search for vintage shots from when they were located in the Ferguson mansion. Others who must be mentioned for their contributions, leads, and support include the following: Mary Bealmear and the estate of Polly and Clarke Wood; Delinda Buie; Charlene Claycomb; Robert Goldstein and Rich May, owners of the Columbine Bed and Breakfast; Linda Gregory; Bob and Norma Laufer; Mary Martin; Todd McGill; Tom Owen; Susan Shearer; Keith Simon; Joan Stewart; and Rudy Van Meter as well as all those who searched valiantly but in vain. Above all, we owe a huge debt of gratitude to my wife, Jane Harris, for her detective work. Without her assistance, this would have been a daunting project. Thanks to each and every one of you for your treasured memories of Old Louisville.

We were privileged to use as our "bible" for this project *The Encyclopedia of Louisville*, edited by Mr. John E. Kleber. It is by far the greatest single resource of Louisville history in existence.

INTRODUCTION

Truthfully I did not know what I was getting myself into after moving to Kentucky in 1993. I had only planned on staying a year, but Louisville, the bustling river city with the split personality—is it northern or southern?—quickly won me over. In addition to wonderful restaurants, a vibrant art scene, and more, it had history. From its different neighborhoods to the legendary racetrack at Churchill Downs, Louisville came across as a city with a story to tell. Racetrack royalty, bourbon barons, titans of tobacco—these were just some of the types that helped shape this river town, and their mark was still indelibly etched on the fabric of the community. And it seemed that one neighborhood in particular embodied this colorful mix of influences: Old Louisville. Situated to the north of the University of Louisville, this 45-square-block area had hundreds of intact mansions and townhomes that comprised one of the largest historic preservation districts in the entire nation.

I soon became one of Louisville's biggest fans and began writing travel pieces extolling the virtues of my adopted hometown—and as time progressed, so did my fascination with Old Louisville. First off, I found it amazing that such a collection of houses existed in a country obsessed with tearing down the old and putting up the new. Secondly it was surprising that this treasure trove of Victorian architecture had been largely overlooked by the rest of the country. It is not every day one comes across an American neighborhood with over 1,000 historic structures after all, not to mention so many in such a compact area.

Almost 20 years later, Kentucky's largest city is still telling stories and revealing its secrets. And Old Louisville continues to fascinate me. So it is only fitting that I should want to share the things that make this exceptional neighborhood worth a visit—or a lifetime stay. One way to do this is by telling its story through photographic images that chronicle its evolution, from inception and heyday to neglect and back. Once a run-down part of town, Old Louisville has reclaimed its position as the queen of neighborhoods thanks to preservation-minded individuals and old-home aficionados like Ron and Jane Harris who refused to let the neighborhood die. The images in this book live on as a testament to the people who made Old Louisville what it was back then and is today, a reminder of an American neighborhood. So sit back, relive a bit of the past, and enjoy.

—David Dominé

My first dream in life was to own a Victorian mansion in Old Louisville.

As a kid growing up in Fairdale, Kentucky, in the sixties, every Saturday I would slop the hogs, sucker the corn, and get all my chores done early so I could take the bus downtown to catch a matinee. On the way in, I would have my nose pressed up against the bus window when we got to Fourth and Hill Streets. That is where the castles began; a stretch of Victorian mansions so opulent that I could not take my eyes off them. They were like something out of the movies with their minarets and turrets, cupolas and stained glass. For a boy from farm country, it was a heady, wondrous place. I still feel that way today.

After 30 years of an acting career in New York City, and particularly after September 11, my wife and I were ready for a kinder, gentler place to live. It was then that I returned to my first dream in life: we sold the house in Brooklyn and bought a 13-room Victorian mansion in Old Louisville.

To this day, Old Louisville is one of the best-kept architectural secrets in the United States of America. A handful of "painted lady" Victorians from San Francisco seem to get all the press. Well here are the statistics, folks: Old Louisville has one of the largest collections of intact Victorian homes in America and one of its largest preservation districts. The area consists of some 50 square blocks containing more than 1,000 structures. It is literally a "who's who" of Victorian architectural styles. Queen Anne, Richardson Romanesque, Chateauesque, Renaissance, and fanciful eclectic blends continually enchant and fascinate passersby. Houses like this will never be built again. It is impossible. Much of the lush paneling and details inside were milled from old growth wood, huge trees that were used up long ago. Given today's population and housing needs, trees never get the opportunity to age 200 and 300 years.

Many people who now live in the burgeoning suburbs south of the metropolis are unaware of the treasures to be had in Old Louisville. New converts from these uninitiated often occur because there is an accident on U.S. Interstate 65. When commuters bale at the St. Catherine exit to take Third Street as an alternate, many are totally in awe of the mansions of Millionaires Row, former residences of distillery owners, tobacco company presidents, and even the owner of Kentucky Derby winners, like Old Rosebud. It is a shame that people living a 20-minute drive away are so unaware of the architectural riches right in their own back yard. It is a situation that we hope to remedy with the publication of this book.

My coauthor, David Dominé, has already begun the work of re-popularizing Old Louisville.

An Old Victorian mansion usually comes with a ghost story or two. With hundred structures in the offing, Old Louisville is the mother lode of such tales—except no one, before David, had ever taken the trouble to write them down! Three volumes later, the tales keep coming and so do the tourists. Old Louisville, fabulous invalid of the metropolitan area, is beginning to once again find the admiration it so richly deserves.

It is time now to sing the unsung.

So find a comfy chair, turn on a good reading lamp, and prepare yourself for the wondrous opulence of a day gone by.

—Ronald Lew Harris

One

ONE HUNDRED DAYS THAT LOUISVILE OPENED ITS DOORS TO THE WORLD

On August 2, 1883, the eyes of the nation turned to Kentucky, as its largest city readied itself for the influx of visitors to the Southern Exposition. On a front page article, *The Courier-Journal* gave readers across the region a glimpse of the delights in store for those who planned to attend: music, art, machinery, literature, gardens, science, industry, and more. At the time, Louisville was not even 100 years old, and the population hovered at around 125,000 residents; nonetheless, in the first 88 days, the early world's fair attracted more than 770,000 people. The city would never be the same. (Ronald Harris Collection.)

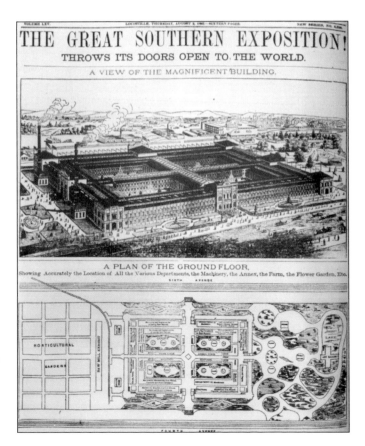

9

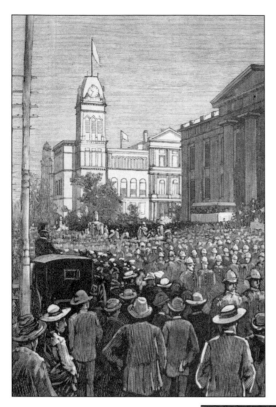

For the grand opening of the Southern Exposition, a magnificent procession started in downtown Louisville—as illustrated here in *Harper's Weekly*—and wended its way south to present-day Old Louisville. Along the way, the procession stopped at the Galt House and escorted the guest of honor, Pres. Chester Arthur, to its final destination. (Ronald Harris Collection.)

Visitors to the Southern Exposition entered the main exhibit hall through a grand gateway on the eastern side of the building. An engraving by H. F. Farney that appeared in the August 4, 1883, edition of *Harper's Weekly* depicts eager crowds as they greet the arriving carriage of Pres. Chester Arthur. Today the Fourth Street gateway for Fountain Court marks the approximate location of the original entryway to the Southern Exposition. (Ronald Harris Collection.)

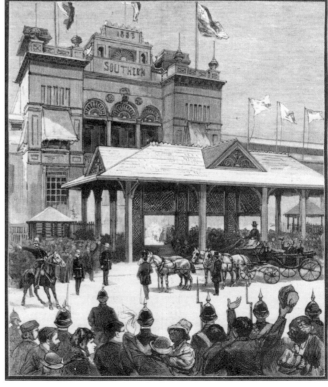

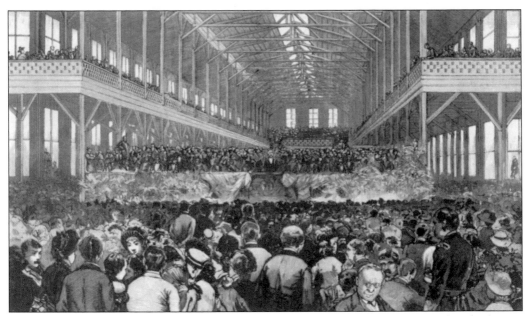

When it opened in Louisville on August 1, 1883, the Southern Exposition counted as the largest single display of agricultural machinery ever held in the country. The main building alone covered nearly 10 acres, and President Arthur officiated at the opening ceremony. In addition to more than 1,500 commercial and mercantile attractions, the Southern Exposition featured a promenade, landscaped picnic grounds, musical and theatrical venues, and an art gallery. (Ronald Harris Collection.)

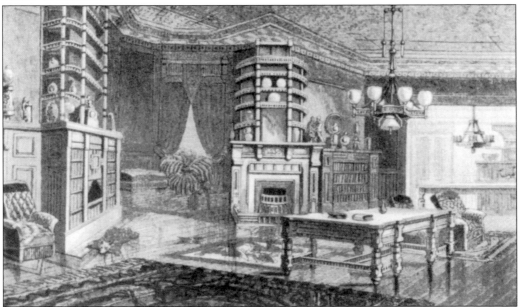

The president was entertained at the lavish White-Carley residence at 835 South Fourth Street during his stay in Louisville. An illustration from *The Art Journal¸ Vol. 6 1880*, depicts the spacious interiors and elegant furnishings that made the mansion one of the most admired in the city. Completed around 1869, the sprawling structure would set the standard for residential architecture in Kentucky's largest city. (David Dominé Collection.)

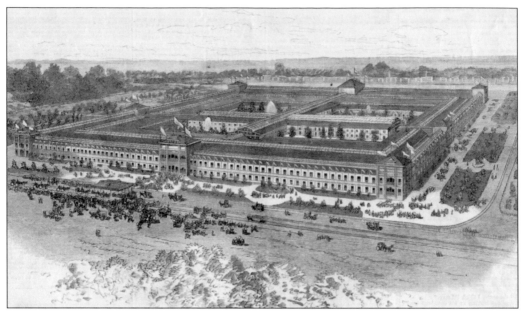

Another view of the main building of the Southern Exposition of 1883 shows the massive proportions of the wooden structure that was built just south of Central Park, or DuPont Square, as it used to be known. The site of the former building, which measured 600 by 900 square feet, is bounded today by Magnolia Avenue to the north, Hill Street to the south, and Fourth and Sixth Streets to the east and west, respectively. (Ronald Harris Collection.)

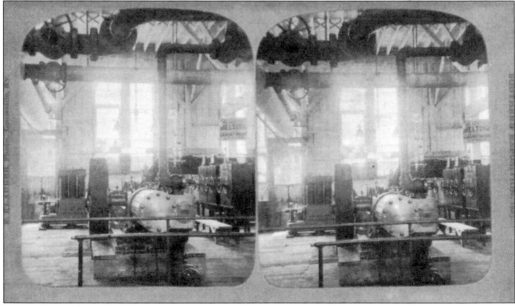

The Louisville Board of Trade developed the Southern Exposition to promote industry and commerce in the South. A stereopticon view from the famous Southern Exposition shows one of the many mechanical exhibits that attracted throngs of visitors to today's Old Louisville in the 1880s. The grounds for the yearly exhibition covered approximately 45 acres and included land where St. James and Belgravia courts and Central Park now stand. (Courtesy of the C. Bagley family.)

Among the many agricultural, scientific, and mechanical displays open to the public, visitors to the Southern Exposition of 1883 found informative exhibits showcasing the states in the South, as seen in this stereopticon slide. With the theme of *Cotton from Seed to Loom*, the fair highlighted the many innovations in the growing of the South's most famous crop. (Courtesy of the C. Bagley family.)

As part of the Southern Exposition, a fireproof art museum was built to house paintings, statuary, and other works of art from the collections of J. Pierpont Morgan, John Jacob Astor, August Belmont, Jay Gould, Victor Newcomb, and the Smithsonian Institution. Also displayed were Ulysses S. Grant's collection of curios and General Sheridan's collection of Gobelin tapestries, in addition to works by local artists. (Ronald Harris Collection.)

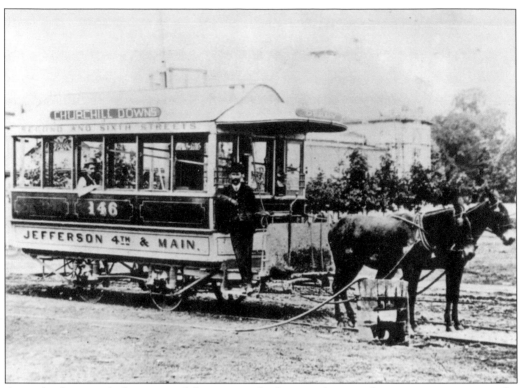

An early photograph shows one of the many mule-drawn railcars used to transport visitors to the Southern Exposition. This shot was taken in front of the art museum, and the driver is Joe Mudd, the last of Louisville's mule-car drivers and a relative of Old Louisville resident Susan Shearer. (Courtesy of Susan Shearer.)

A close up of an engraving from a *Harper's Weekly* in 1883 depicts one of the numerous exhibits that brought a glimpse of foreign cultures to the people of Kentucky. As in other parts of the country, Victorians in Kentucky displayed a fascination for exotic lands, especially those in the Orient. (Ronald Harris Collection.)

Among the most popular cultural exhibits at Louisville's Southern Exposition was the Swiss display, as seen in this engraving from a *Harper's Weekly* in 1883. For its contribution, Switzerland featured a chalet-inspired building and dirndl-wearing ladies on hand to talk about the alpine nation. Among the sizeable numbers of German speakers in the Louisville area were many Swiss immigrants who had settled in southern Indiana. (Ronald Harris Collection.)

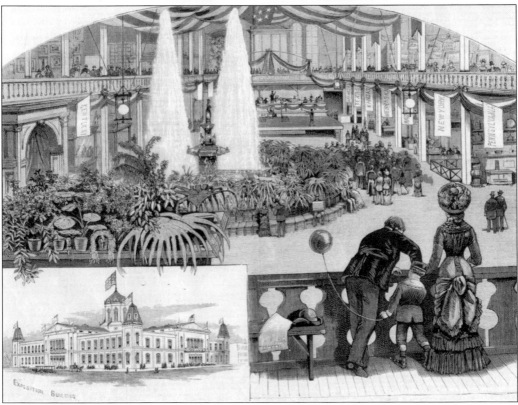

In anticipation of the Southern Exposition to be held in Louisville, *Frank Leslie's Illustrated Newspaper* in 1882 featured several articles touting the success of an earlier fair held in that city. In addition to an inside view of the main hall, this engraving shows the exterior of the exposition building of 1873 as well. (David Dominé Collection.)

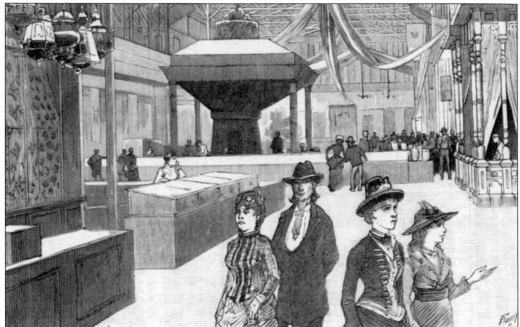

For many residents in Kentucky and neighboring states, a visit to the Southern Exposition in Louisville became an annual event; it was not uncommon for visitors to spend at least a week or two enjoying the various exhibits and cultural events such as outdoor concerts, theatrical productions, and lectures. A visit to the Southern Exposition often began at the central nave of the main exhibit building, as depicted in this engraving that appeared in *Harper's Weekly*. (Ronald Harris Collection.)

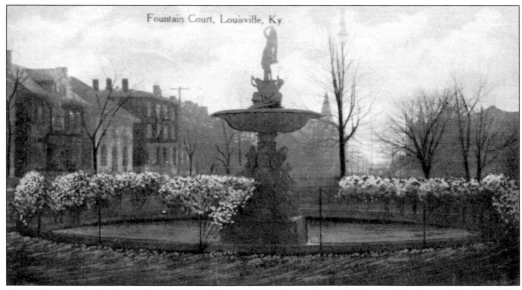

Fountain Court, Louisville, Ky.

An early postcard shows the statue of Venus that sits at the midpoint of St. James Court today; during the 1880s, this would have been the location of the central nave of the Southern Exposition. Installed on the center green of the court in 1892, the bronze fountain was created at the Mott Foundry in Brooklyn and is one of the city's most famous landmarks. (Courtesy of the Conrad-Caldwell House.)

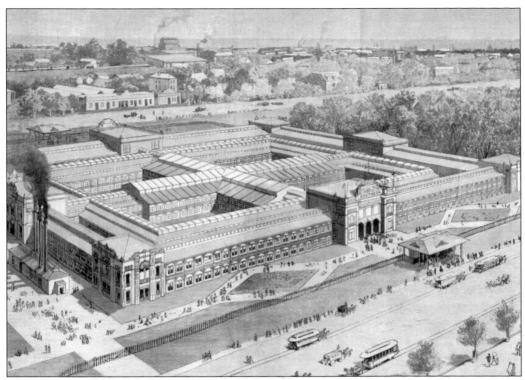

The Louisville Board of Trade hired Thomas Edison—a one-time resident of Louisville—to illuminate the massive exposition building at nighttime. A total of 5,000 incandescent lamps, were used—4,600 for the main hall and 400 for the art gallery, more than all the lamps installed in New York City at that time. (Courtesy of Martin Smith.)

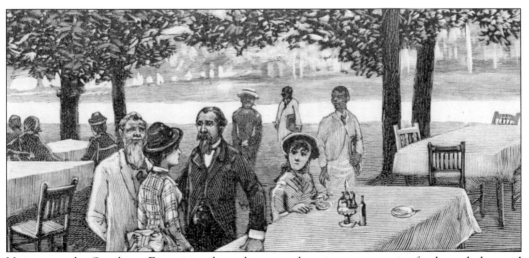

Visitors to the Southern Exposition brought more than just an appetite for knowledge and entertainment. As a result, a number of restaurants and watering holes sprang up to cater to hungry and thirsty attendees. In addition to food stalls offering regional and international specialties, there was also a popular park pavilion that provided fine dining. (Ronald Harris Collection.)

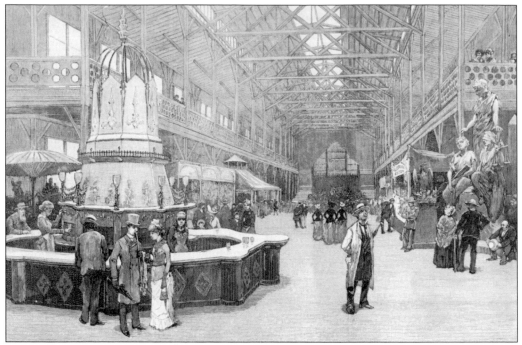

An engraving from *Harper's Weekly Supplement* depicts a typical weekday afternoon at Louisville's Southern Exposition of 1883, where strategically placed beverage bars offered refreshment for visitors strolling from attraction to attraction. Raised galleries in each of the naves afforded bird's-eye views of the mechanical exhibits and artistic displays. (Courtesy of Maleva Tubbs.)

Exhibits at the Southern Exposition included informative displays from each of the 38 states in the union. As part of its contribution to the Southern Exposition, California sent cross sections of its famous redwood trees. Held in the late summer and fall for five years starting in 1883, the Southern Exposition attracted millions of people from all over the United States and abroad. (Ronald Harris Collection.)

Two

BUILDING BOOM

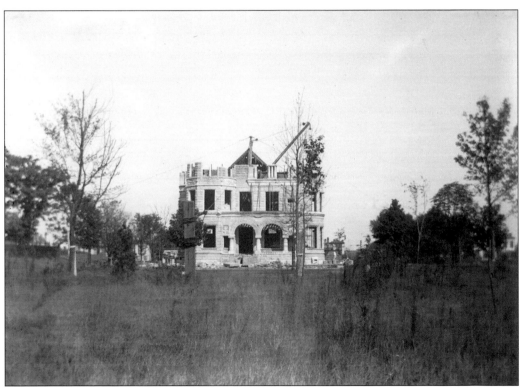

This is a rare 1890s photograph of the Conrad-Caldwell House while under construction at 1402 St. James Court. Known as "Conrad's Folly" at the time because of its cost ($75,000) and distance from downtown, it was built for local leather manufacturer Theophilus Conrad and designed by Arthur Loomis of the architectural firm of Clarke and Loomis. The still-rural nature of the area is apparent. (Courtesy of University of Louisville Photographic Archives.)

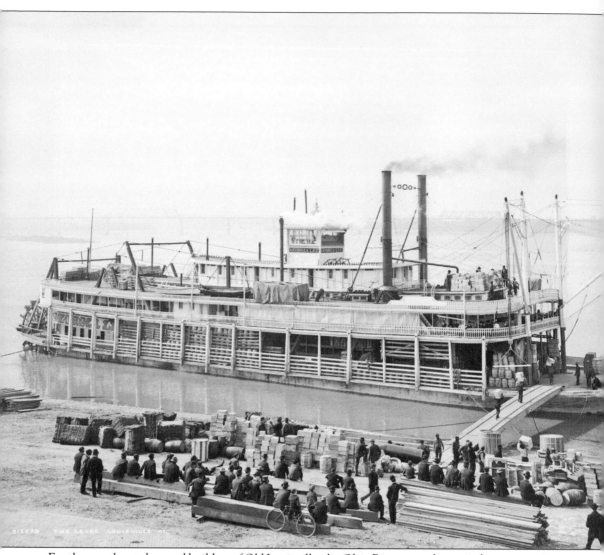

For the merchant class and builders of Old Louisville, the Ohio River served as a vital transportation hub for the delivery of goods and services to river towns that the railroads did not reach. In this two-shot panorama of the Louisville Levee, the steamboat *Georgia Lee* is being loaded for a trip downriver. Well-dressed passengers stand at the upper railing watching the work progress. Along the dock, a variety of goods including spools of hemp rope, axle grease, and hogsheads of tobacco

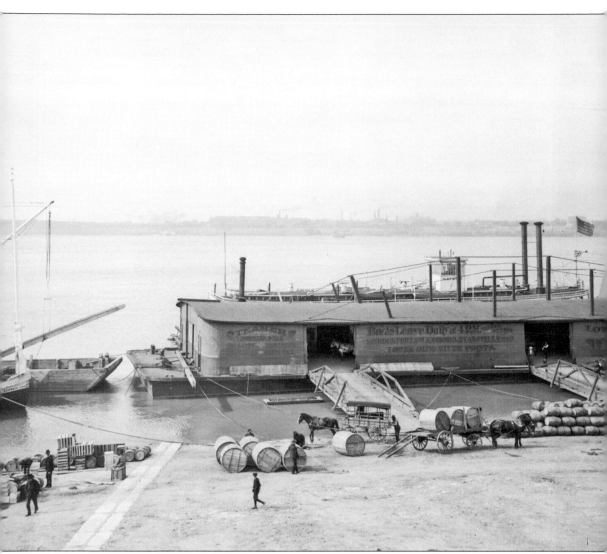

can be seen. To the far left, bales of cotton, probably just off-loaded, lie in a jumble. In the right-hand photograph, the flatboat headquarters of a steamer company advertises itself: "Steamers Morning Star, Tell City, Tarascon, John W. Thomas, and Bellevue—Boats leave daily at 4 p.m. except Sunday for Rockport, Owensboro, Evansville and lower Ohio River ports." (Library of Congress, Prints and Photographs Division, Detroit Publishing Company Collection.)

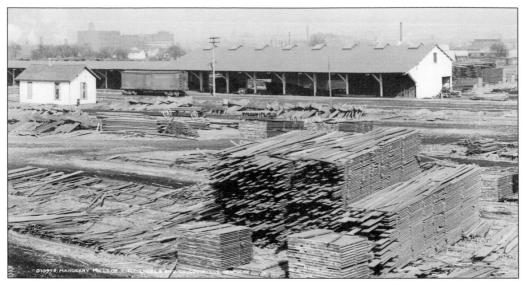

Though some supplies for the building boom came through the levee, there was also a number of brick manufacturers and lumberyards in the immediate vicinity. One of the largest, the firm of Clarence and Robert Mengel, was situated to the west of Old Louisville, near the railroad tracks. Although they specialized in mahogany, other native and exotic woods were available. With fine woods from the Mengel mill, craftsmen produced trimmings and furnishings to adorn the newly constructed mansions of Old Louisville. (Library of Congress, Prints and Photographs Division, Detroit Publishing Company Collection.)

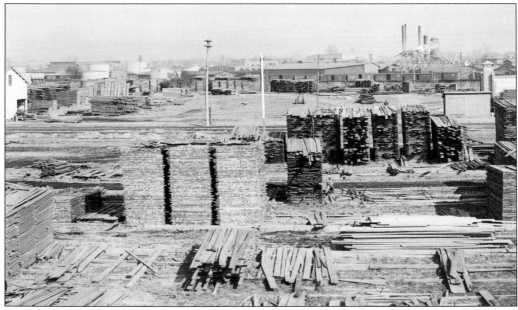

C. C. Mengel, the father of Clarence Jr. and Robert Mengel, formed the Mengel Box Company after the Civil War. In addition to household furnishings, they specialized in wooden washing machines and boxes of varying sizes. The company also owned mills in Belize and Arizona. Business boomed. By the 20th century, they had their own fleet of ships for transport to the United States. Upon arrival, the logs would be loaded onto company railcars headed for Kentucky. (Library of Congress, Prints and Photographs Division, Detroit Publishing Company Collection.)

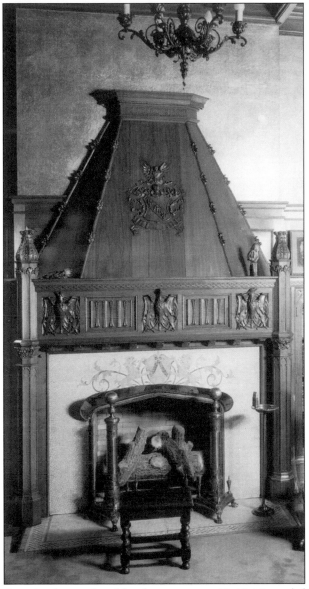

The elaborate fireplace in the study of lumber magnate C. C. Mengel displays the level of craftsmanship that characterized Louisville's building boom in the late 1800s. In addition to state-of-the-art amenities such as gas fireplaces in each room, residences were outfitted with quality millwork and intricate fixtures such as ornate mantels that were often carved on-site. Flanked by a bank of built-in bookcases, the Mengel fireplace has a mosaic tile surround and carved hood that is reminiscent of larger fireplaces in German and French castles. Apart from the Mengel family crest, the carved wood includes decorative finials with acanthus leaves and three *Reichsadler*; also known as imperial eagles, these heraldic birds of prey were recognized symbols in the Mengel family's native Germany. C. Mengel founded the company in the late 1800s, and his sons C. Robert and C. Clarence would take it over around 1900. Furniture, boxes, toys, and other wooden items were made in the early years, and in the 1930s, the company started manufacturing wooden playthings for Walt Disney. The company was bought by Kroehler Manufacturing Company in 1956. (Courtesy of Raymond Morgan.)

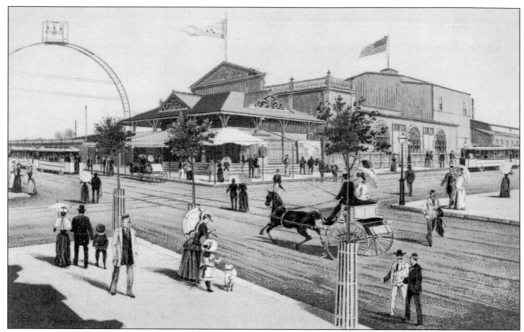

Although new building supplies were available from companies such as the Mengel's, there was also a ready supply of used lumber when the Southern Exposition was torn down in the late 1880s. One structure built from recycled materials was the Amphitheatre Auditorium, which stood on the southwest corner of Fourth and Hill Streets from 1889 to 1904. The second-largest theater in America at the time, it had 3,072 seats and an adjoining 10,000-seat fireworks amphitheatre. (Courtesy of University of Louisville Photographic Archives.)

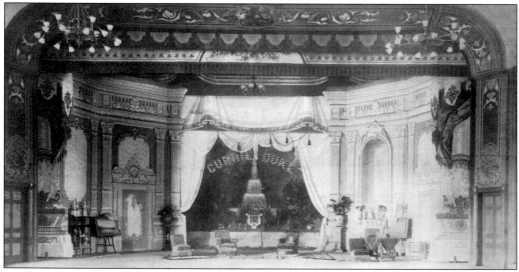

Seen here is a rare interior shot of the Amphitheatre Auditorium, which was run by the eccentric William F. Norton Jr. Norton went by the name of Daniel Quilp to avoid upsetting his strict Baptist family. (Norton's mother once pronounced the theater "hell's waiting room.") The theater complex hosted many great performers such as Edwin Booth, Sarah Bernhardt, and John Phillip Sousa and contained a bike riding park, a promenade, a man-made lagoon, and a wildlife park. (Courtesy of University of Louisville Photographic Archives.)

24

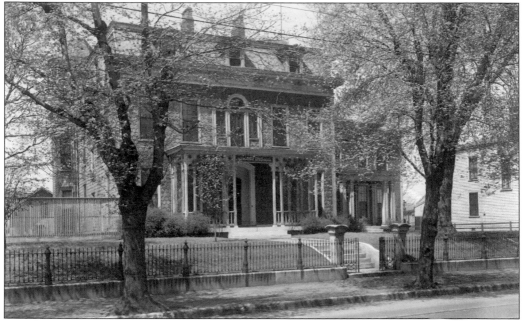

The Slate House at 1412 South Sixth Street takes its name from the octagonal slate tiles used for siding—tiles salvaged from the roof of the Great Southern Exposition (1883–1887). The Jennie Cassaday Free Infirmary for Women was established in this house in 1892. When an 1861 carriage accident left her paralyzed, the young philanthropist dedicated the rest of her bedridden life to helping others. (Courtesy of University of Louisville Photographic Archives.)

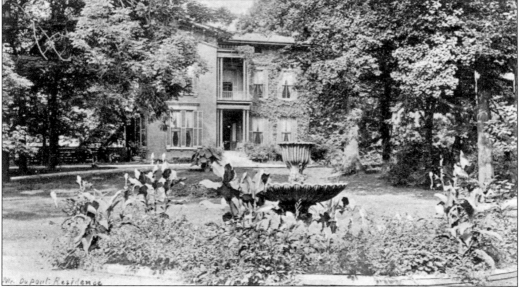

An old photograph shows one of the first mansions in the neighborhood, the residence of Antoine Bidermann and Alfred Victor du Pont, which was constructed atop a low crest in today's Central Park. Built in the mid-1800s of brick-and-mortar, the modest Italianate structure typified the earliest homes built in the area that would become Old Louisville. The mansion was razed around 1905 when the city acquired the land and redesigned it as a formal park. (Courtesy of University of Louisville Photographic Archives.)

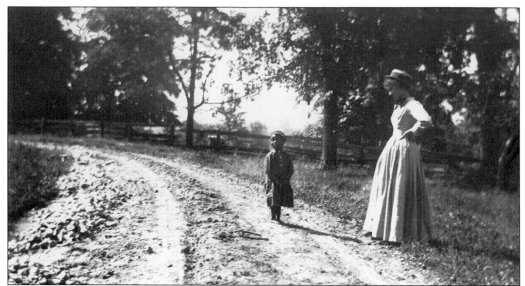

This African American mother and child are pictured on the edge of what would become Louisville's Central Park. This photograph, taken in the early 1890s, gives the viewer an idea of just how rural the area was prior to development by the Victoria Land Company. The fencerow seen in the background represents the edge of the du Pont estate, acquired by the parks board in 1904. (Courtesy of University of Louisville Photographic Archives.)

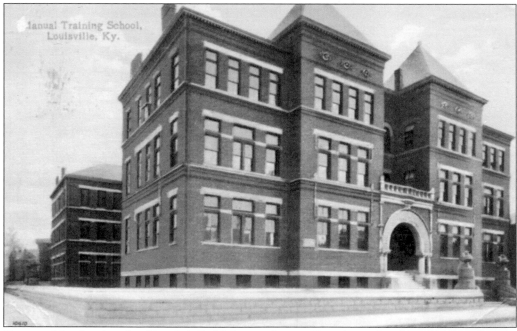

Dismayed by the dearth of local skilled laborers, Louisville industrialist Alfred Victor du Pont donated $150,000 to the board of Louisville Public Schools in 1892—with the express intent of establishing a training institute to teach young men the manual skills needed in the workforce. A year later, a sturdy Victorian structure was built on the corner of Brook and Oak Streets by the firm of Clarke and Loomis. Today the old du Pont Manual Training High School is an apartment building. (Ronald Harris Collection.)

To mark the center of the Southern Exposition, city planners had an ornate statue with a Venus centerpiece installed in the middle of St. James Court. A postcard from the early 1900s depicts a view of this fountain from the south, with the entrance to picturesque Fountain Court to the east. Walking courts—private green spaces at residents' front doors instead of paved streets—made St. James Court and its environs the most desirable of residential quarters in Kentucky's largest city. (Courtesy of Conrad-Caldwell House Museum.)

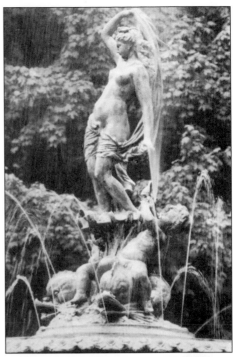

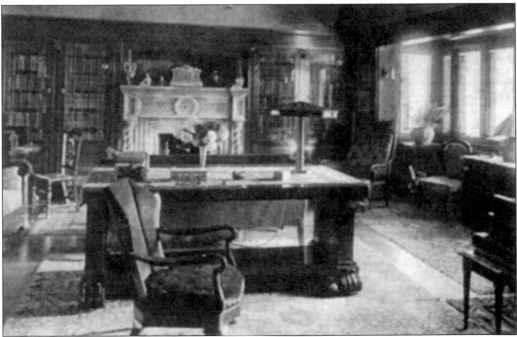

Architects were needed to keep up with the demand for new houses in Louisville's first suburb. One of them was Canadian-born William J. Dodd, an American architect and designer who worked in Kentucky from 1886 to 1912. In a prolific career that spanned five decades, Dodd produced numerous structures, many of which survive today. One of them is his home on St. James Court; the library, as seen here, was featured in the 1912 catalogue for the Louisville Chapter of the American Institute of Architects.

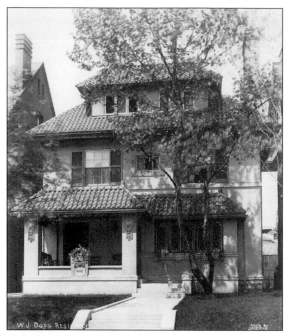

Architect William J. Dodd built 1448 St. James Court to be his residence. From 1896 to 1913, Dodd and various partners contributed greatly to the beauty and architectural richness of Louisville. The Ferguson mansion, Jefferson Community College, St. Paul's Episcopal Church, and the Seelbach Hotel, as well as residences for Alfred Brandeis and Louis Seelbach, all saw his deft touch. (Courtesy University of Louisville Photographic Archives.)

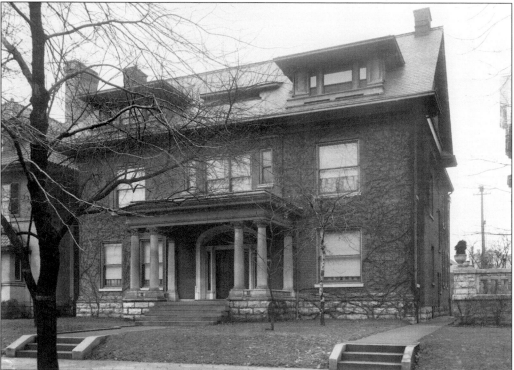

Poet Cale Young Rice built 1444 St. James Court for him and his wife, the former Alice Caldwell Hegan, author of *Mrs. Wiggs of the Cabbage Patch*. The house was so wide that Rice bought an adjacent lot, so that he would have the extra 15 feet needed for the design. Consequently 1448 (next door) sits on the narrowest plot on the court. (Courtesy University of Louisville Photographic Archives.)

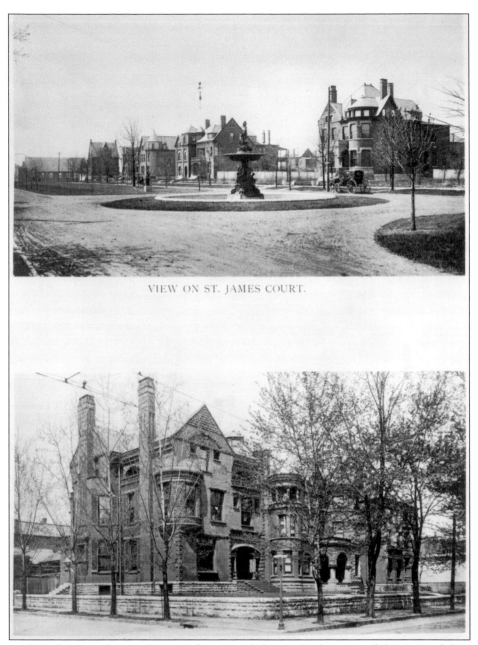

VIEW ON ST. JAMES COURT.

Unpaved roadways and several vacant lots reveal the seminal nature of the turn-of-the-20th-century view of St. James Court (pictured above). Sparse, newly planted trees draw a sharp contrast to the leafy bower that is the court today. Building lots sold slowly until the Victoria Land Company marketed to "snob appeal" of Victorians by basing the layout and names on the residential parks of London, England. Built in 1884, the corner structure (1332 South Fourth Street) was originally home to Russell Houston, a well-known attorney and president of the Louisville and Nashville Railroad. The 7,400-square-foot Richardson Romanesque mansion has often been called the "Queen" of Old Louisville. In 2001, it was purchased by Gayle and Herb Warren and is now the home of the Inn at the Park Bed and Breakfast. (Both courtesy University of Louisville Photographic Archives.)

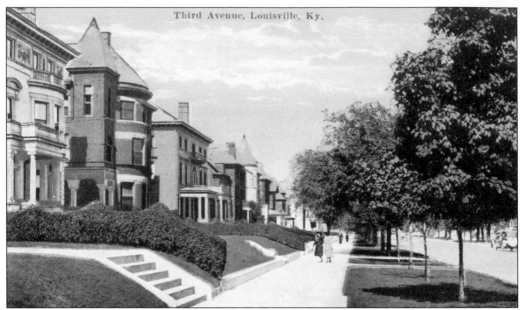

St. James Court counted as only one enclave for the well-to-do in the growing neighborhood. Many movers and shakers chose to build lavish residences along Third Street. An early postcard of the 1400 block depicts the stunning variety of architectural styles that typified the mansions of Louisville's Millionaires Row. Known for the exuberance of its architecture and design, Old Louisville drew on a wealth of local talent to shape the appearance of the burgeoning streetscapes. (Courtesy of Charlene Claycomb.)

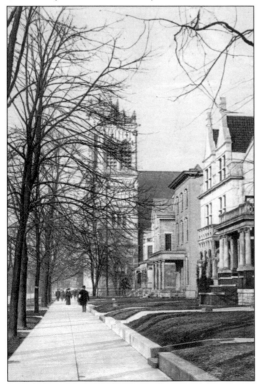

The first thoroughfare to be paved in Kentucky's largest city, Third Street—once known as Third Avenue—included wide sidewalks and shade trees to encourage evening strolling and weekend promenading. Many Louisvillians referred to it simply as "the Promenade" or "the Street" during the neighborhood's heyday from the 1880s to the 1920s. This photographic image from the early 1900s depicts one segment of the stretch of mansions that once extended from Broadway all the way to the University of Louisville. The spires of Walnut Street Baptist Church can be seen in the background. (Ronald Harris Collection.)

TO BOYCOTT LOUISVILLE CHURCH

Fashionable Third Avenue Residents Indignant at Baptist Congregation's Action.

Special to The New York Times.

LOUISVILLE, Ky., Sept. 11.—The Walnut Street Baptist Church, the richest and largest congregation in the South, recently sold its old church in the business part of the city on Fourth Street and bought a fine lot on Third Avenue, the best residence street in Louisville.

It has begun the erection of a church which is to cost $150,000, but to the amazement of the residents the building line will be ignored and the edifice will go up from the sidewalk. As Third Avenue contains the finest homes in Louisville, and as they have been built back over thirty feet from the sidewalk, the plans for the church will destroy a beautiful view.

The residents are greatly excited over the matter, but the church will not yield. To-day John T. Gathright, whose property adjoins the church, took out a permit for a sixty-foot fence, with which he will cut off the church from his property and also from the sight of the avenue. Mr. Gathright says that when he asked the pastor of the church, Dr. Eaton, not to disregard the building line, as it would depreciate the value of residence property, the minister replied that the church would buy the land when it got cheap.

The church will be boycotted by the mansion owners.

The New York Times

Published: September 12, 1900

Copyright © The New York Times

Growth in Old Louisville was not without its problems, however. In September 1900, the *New York Times* reported on a dispute between mansion owners and the Walnut Street Baptist Church. Although deed restrictions required that all Third Street property owners build structures 30 feet back from the street, the church chose to ignore this agreement—for motives explained in the article.

In this photograph, the former residence of solicitor John T. Gathright, the leader of the boycott against the Walnut Street Baptist Church, can be seen years after the church "bought the land when it got cheap." A structure was built across the facade, and today the peak of a solitary gable jutting above the newer addition is the only clue that a house was built there. The church now uses the building for its Christian Social Ministries. (David Dominé Collection.)

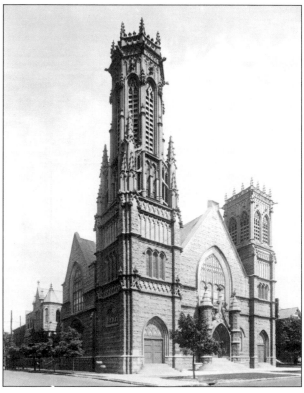

The magnificent Gothic towers of the Walnut Street Baptist Church grace the corner of Third Street and St. Catherine Street. When it was completed in 1902, it caused great consternation in the neighborhood because the edifice was constructed without a landscaped setback, unlike every other property along Third Street. The structure has large stained-glass windows on three sides and a 10-bell tower chime. (Courtesy University of Louisville Photographic Archives.)

Newly planted saplings can be seen in this photograph from the 1890s, which provides one of the very first glimpses of Second Street. Taken from the front steps of the home of William E. Caldwell at 1310 South Second Street, the image provides insight into what much of today's Old Louisville would have looked like in the last decade of the 19th century. (Courtesy of the Caldwell family.)

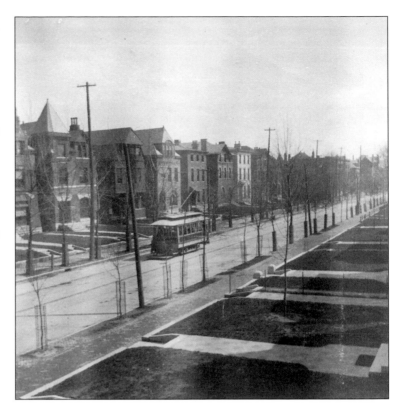

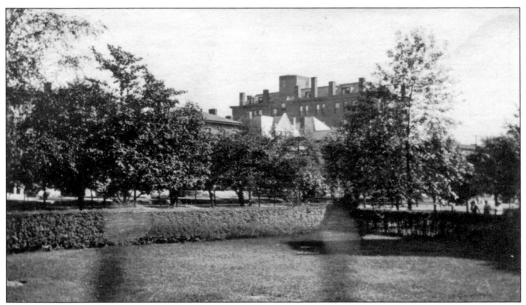

The building boom in Louisville's first suburb was not limited to the construction of lavish mansions and comfortable single-family dwellings. A number of apartment buildings went up in the late 1800s, including the one seen in this rare photograph taken from the top floor of the St. James Court residence of Theophilus Conrad. The top stories of the St. James Apartments were removed after a fire in 1912. (Courtesy of the Caldwell family.)

An advertisement from the April 22, 1889, *Courier Journal* shows another construction company that arose to meet the needs of the building boom in Kentucky's largest city. By 1900, the neighborhood known today as Old Louisville was saturated with comfortable new dwellings for the moneyed classes, and more suburbs would arise throughout the Derby City to accommodate the ever-increasing number of residents.

34

Three

CITY OF BEAUTIFUL HOMES

"Beautiful and practical homes line the streets and dot the open country, houses which give to the city her well-deserved title of City of Homes," so was the description of Old Louisville in the January 28, 1900, edition of *The Courier-Journal*. Attractive on the outside and often lavish on the inside, homes such as the Third Street residence of C. C. Mengel Jr. cultivated Louisville's image as a city of beautiful homes. (Courtesy of Raymond Morgan.)

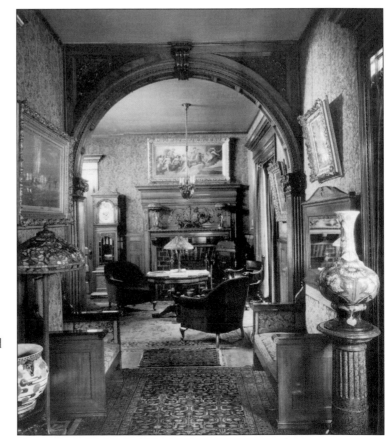

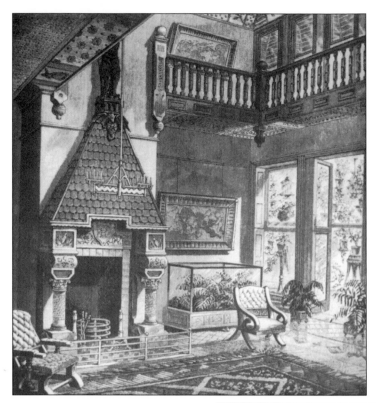

One of the most beautiful homes in the city at the time, the White-Carley residence at 835 South Fourth Street had an elaborate hallway that was featured in *The Art Journal,* Vol. 6, 1880. Built in 1869, it met the fate of so many of the grand mansions that dotted the area immediately south of Broadway: demolition. (David Dominé Collection.)

This elaborately ornate mansion at 1118 South Third Street was built in 1888 for Kilbourne W. Smith, an agent for the Mutual Benefit Life Insurance Company. With its blend of Romanesque and Queen Anne details, the residence has come to epitomize the exuberance of styles that evolved in today's Old Louisville as a result of the wealth of local architectural talent. Comfortable dwellings, lavish mansions, and plentiful green spaces earned Louisville the nickname as "the City of Beautiful Homes." (Courtesy University of Louisville Photographic Archives.)

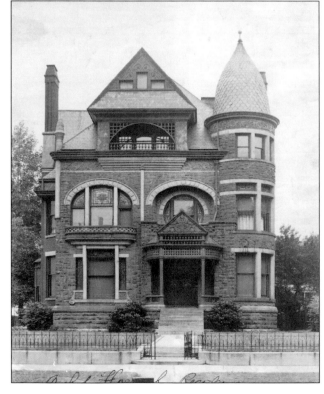

A rare photograph from the 1890s shows another view of the Third Street home of Kilbourne W. Smith. The liberal use of polychrome stone and multi-textured surfaces made it one of the most admired pieces of architecture in the city. In 1927 it became the residence of John Alexander Floersh, the archbishop of Louisville. Among his many accomplishments, Floersh established Catholic Charities, the annual Corpus Christi processions and St. Thomas Seminary. (Courtesy of the Caldwell family.)

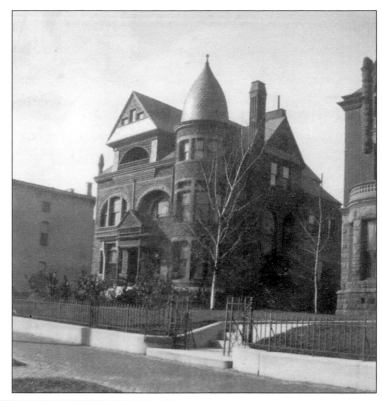

Another fashionable Old Louisville home was the Third Street residence of tobacco broker Charles Bockee, which was built at the onset of the boom that would populate the neighborhood with hundreds of new residences. A striking feature was the keyhole motif incorporated in the front entry and the third-floor balcony, details featured in a *Harper's Weekly Supplement* article from 1888 touting the city's impressive growth. (David Dominé Collection.)

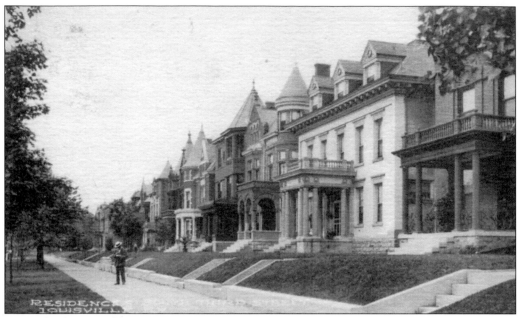

An early photographic image depicts a residential stretch of Third Avenue—originally Third Street—in the waning days of the building boom. Celebrated for many years as Millionaires Row, this street was known for its enviable collection of grand mansions and architectural styles. As seen here, Richardsonian Romanesque, Queen Anne, and neo-Georgian influences would leave their marks on Millionaires Row. (Courtesy of Charlene Claycomb.)

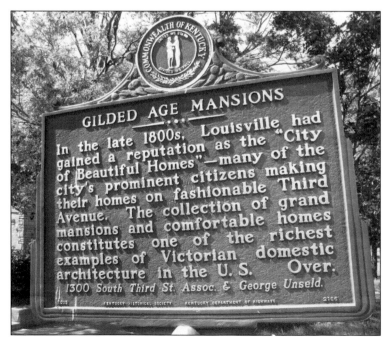

By the late 1800s, at the height of the Gilded Age, today's Third Street was one of the most desired addresses in the city. A historical marker at 1228 Third Street commemorates the impressive collection of Victorian mansion and domestic architecture that garnered Louisville the moniker as "the City of Beautiful Homes." (David Dominé Collection.)

By the late 1800s, Fourth Street had emerged as the principal downtown corridor for business and pleasure in Louisville. When the area to the south emerged as an elite residential enclave, Fourth Street naturally extended and became one of the prime addresses in the city. Renamed Fourth Avenue, it saw the addition of many lavish mansions, such as this one that appeared in *Harper's Weekly Supplement.* (David Dominé Collection.)

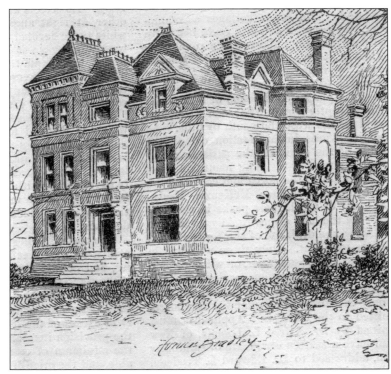

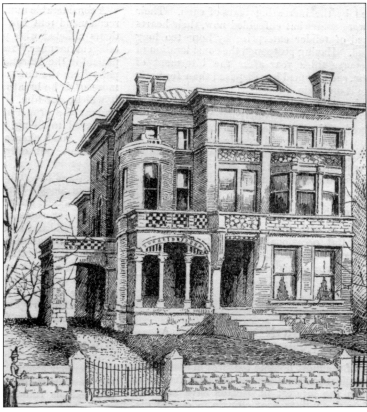

Among the Louisville homes that artist Horace Bradley illustrated for readers of *Harper's Weekly* was this large house near the corner of Fourth and Ormsby Streets. Although it was eventually razed, the brick structure typified the earliest mansions built for the elite of the city's first suburb. (David Dominé Collection.)

Built in 1885, the Fourth Avenue home of vinegar manufacturer Vernon Price sported a distinct facade covered in rough polychrome fieldstone with squared columns and carved capitals supporting the front porch. The attention to details carries over to the interior, where hand-carved fireplace mantels, elaborate millwork, and stained glass adorn the mansion's 18 rooms. Today the home of Vernon Price is a comfortable bed-and-breakfast known as the Central Park Inn. (Courtesy of Bob and Eva Wessels.)

Although many of the mansions that earned Louisville the nickname "the City of Beautiful Homes" remain, large numbers of structures were destroyed in the years following World War II in the name of urban renewal. One of the Old Louisville structures that was lost was this modern Colonial residence that sat on the northeast corner of Fourth and Park Streets. Built around 1884 by Henry J. Tillford, it was featured in the January 7, 1888, *Harper's Weekly Supplement*. (David Dominé Collection.)

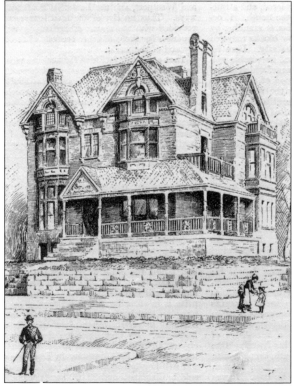

One of the surviving structures in Old Louisville, this eclectic residence with Queen Anne influences was home to the widow Catherine Short. Built around 1886, the house sits across from Central Park and is characterized by decorative brickwork, a shifting roofline, and lack of symmetry highlighted by a variety of planes. (David Dominé Collection.)

Another of Old Louisville's architectural treasures sacrificed in the name of progress was this rambling mansion at 1625 Third Street, mistakenly described as "a lovely Queen Anne" on Fourth Street when featured in the January 7, 1888, *Harper's Weekly Supplement*. Built around 1887 for George H. Hoertz, the house had more than 20 rooms and 15 fireplaces. (David Dominé Collection.)

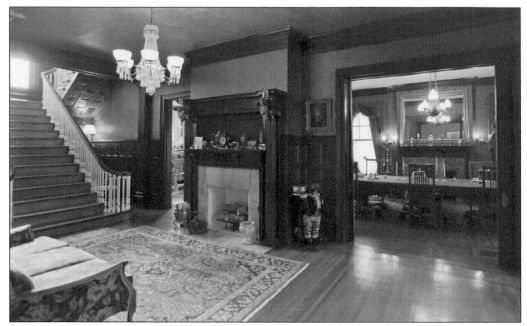

Despite the destruction of so many architectural treasures that characterized urban renewal in this country, Old Louisville has managed to retain many of its grandest mansions. One of them is the Third Street residence of "Mahogany King" C. Robert Mengel. Among the examples of Victorian craftsmanship are rare Honduran wood panels, beautiful fireplaces with rare Carrara marble, and a regal dining table with intricately carved chairs. (Courtesy of Robert Goldstein and Richard May.)

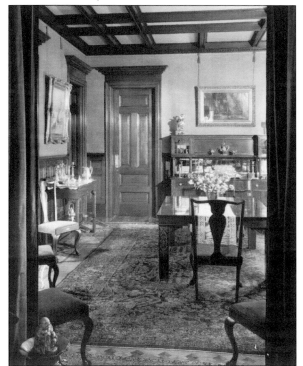

C. Robert's brother, Clarence, occupied an imposing Georgian Revival mansion at 1325 South Third Street that still stands. One of the neighborhood's grandest and most beautiful mansions, it has 12 bedrooms and 14 fireplaces. One of the fireplaces is in the dining room, which was captured in this image from the early 1900s. (Courtesy of Raymond Morgan.)

Four

CONRAD'S CASTLE

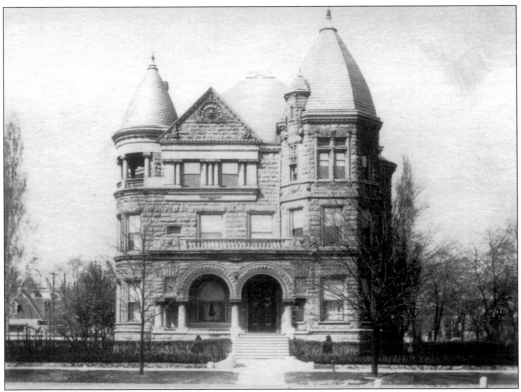

One of the most beautiful—and spectacular—of Old Louisville homes is the mansion built for Alsatian immigrant Theophilus Conrad at 1402 St. James Court. Local architect Arthur Loomis constructed the Richardsonian Romanesque masterpiece between 1892 and 1895, at a cost of $75,000. Dubbed "Conrad's Castle" by locals, the imposing limestone for its outer walls was quarried in nearby Bedford, Indiana. The impressive structure arose at the height of the building boom that would shape modern-day Old Louisville. (Courtesy of the University of Louisville Photographic Archives.)

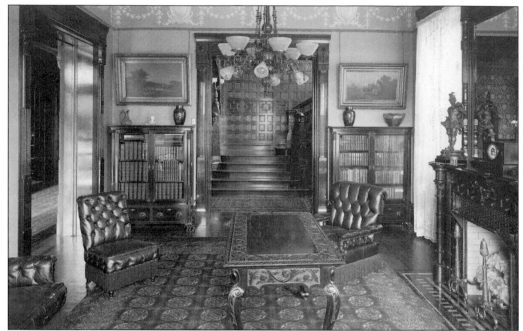

Theophilus Conrad lived in his St. James Court mansion for 10 years before he died there. Soon thereafter his widow sold the house and moved out, and the subsequent occupants redesigned much of the interior. A favorite room of his was this study at the front of the house. (Courtesy of the Conrad-Caldwell House Museum.)

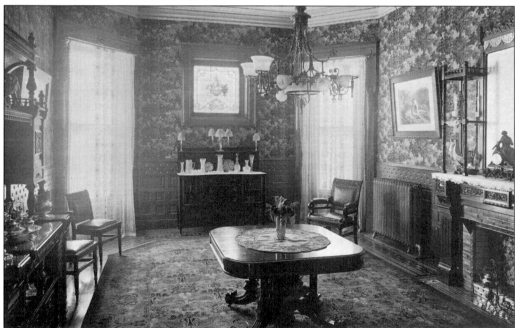

Like most rooms in the Conrad household, the dining room originally had a light fixture outfitted for both gas and electric power. Because of Thomas Edison's involvement with the Southern Exposition, most of the homes built in Old Louisville were equipped for electricity, a sometimes unreliable source of power that required a backup. (Courtesy of the Conrad-Caldwell House Museum.)

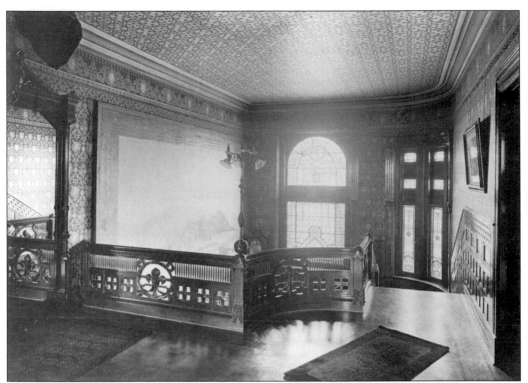

The second-floor landing at the top of the grand stairway in the Conrad family mansion shows the level of attention to detail visible in a typical residence for the Victorian upper class. The railing around the stair features a common Old Louisville motif, the fleur-de-lis, which also was a symbol of Conrad's native Strasbourg. (Courtesy of the Conrad-Caldwell House Museum.)

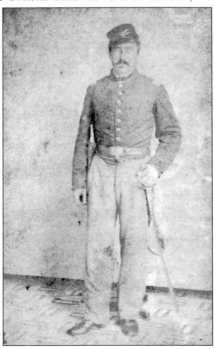

In the mid-1800s, the young Theophilus Conrad arrived in Louisville, having recently finished his apprenticeship as a leather tanner in Europe; eventually this trade would earn him a fortune and make him one of the wealthiest men in the city. A rare early photograph from the 1860s shows him in uniform as a member of the Kentucky Home Guard during the Civil War. (Courtesy of the Conrad-Caldwell House Museum.)

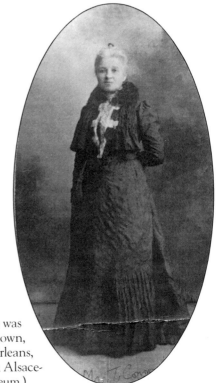

Notes on the back of Conrad's photograph show that he was born in 1832 in Strasbourg, France, and died in 1905. When the Civil War broke out, he had just established the tannery business that would make him one of the wealthiest men in the city. (Courtesy of the Conrad-Caldwell House Museum.)

A rare photograph shows Mary Conrad, née Krieger, who was born in Indiana. Theo, as the young Mr. Conrad was known, met his future wife after moving to Louisville from New Orleans, the city where he initially settled upon immigrating from Alsace-Lorraine. (Courtesy of the Conrad-Caldwell House Museum.)

Seen here is Mena Conrad Hegewald, one of the four daughters born to Theophilus and Mary Conrad. Another Conrad daughter, Emma Albertine, would be the mother of Hattie Cochran, the real-life inspiration for the *Little Colonel* books written by Old Louisville author Alice Hegan Rice. (Courtesy of the Conrad-Caldwell House Museum.)

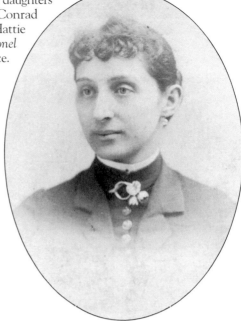

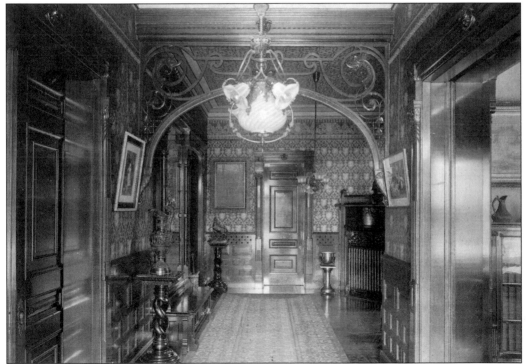

The entry hall at the home of the Theophilus Conrad family featured lavish woodwork with intricate details such as coffered wainscoting and delicate spandrels like the one seen in this photograph taken in the first decade of the 1900s. Although the interior of the mansion was redesigned by the Caldwells after they moved in around 1905, most of the original millwork and hand-carved wood remains. (Courtesy of the Conrad-Caldwell House Museum.)

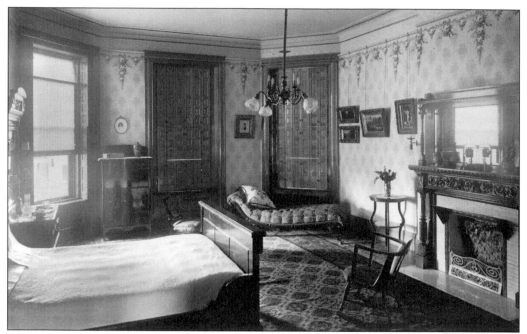

Although Victorian bedrooms tended to be rather austere compared to other spaces in the house, the Conrad family sleeping areas were comfortable as well as spacious. This second-floor room has all the trappings of a turn-of-the-20th-century bedroom, including a chaise lounge and artwork on the walls. A gas fireplace with asbestos heat reflector provided warmth during the fall and winter months. (Courtesy of the Conrad-Caldwell House Museum.)

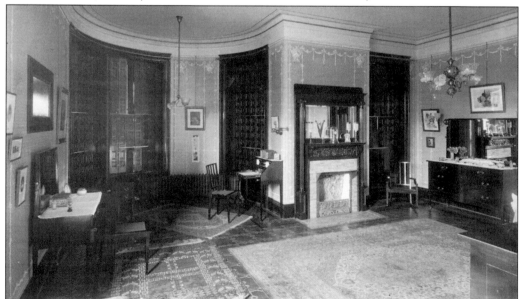

This spacious, well-appointed room on the second floor was set aside for guests of the Conrads. There was a dressing table for madame, a writing desk for correspondence, two bureaus, and even a cozy rocker by the fireplace. The windows in the curved wall have a view looking southward down the court. Multi-paneled mahogany shutters allowed guests to sleep late if they were so inclined. (Courtesy of the Conrad-Caldwell House Museum.)

Five

GILDED AGE GRANDEUR AND EDWARDIAN ELEGANCE

An interior focal point of the Theophilus Conrad residence is the grand stairway with its coffered paneling, stained glass, and elaborately carved woodwork. Constructed in the waning days of the 19th century, its grand interior displays the level of craftsmanship that would typify Old Louisville's mansions of the Victorian and Edwardian eras. The elegant stairs are still an admired feature today, especially among the many visitors who tour the house every year; in 1987, it was restored as the Conrad-Caldwell House Museum. (Courtesy of the Conrad-Caldwell House Museum.)

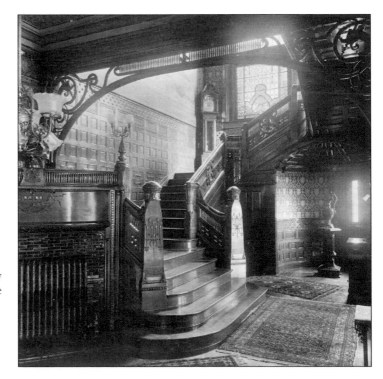

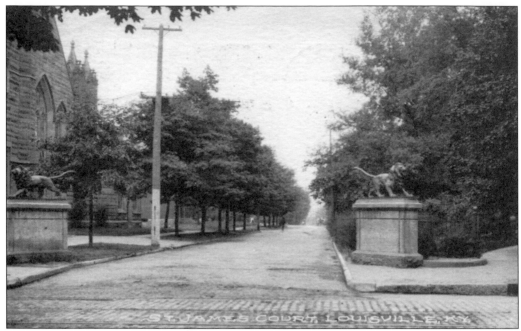

Completed in 1895, the home of Theophilus Conrad constitutes just one of dozens of Gilded Age residences built around St. James Court. A vintage postcard shows a pair of lions—the symbol of St. James Court in London—that at one time graced the entrance to St. James Court at the corner of Fourth Street and Magnolia Avenue. Central Park is to the right, and St. Paul's Church is to the left. Another pair of lions greeted visitors arriving through the corner of Sixth Street and Magnolia Avenue. (Courtesy of Charlene Claycomb.)

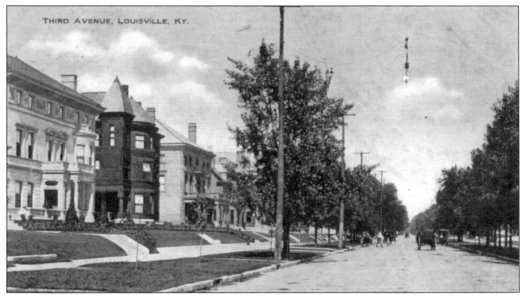

A bastion of Gilded Age grandeur in Old Louisville, Third Avenue emerged as the preferred address for many of the city's millionaires and movers and shakers. Seen in this early postcard image are the mansions of distiller Samuel Grabfelder (left) and future president of Churchill Downs, Samuel Culbertson (third from the left). (Courtesy of Charlene Claycomb.)

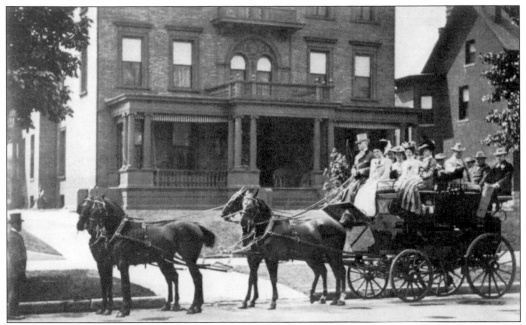

In front of the Culbertson family mansion, a liveryman stands at the ready as Samuel Culbertson prepares to drive his carriage—and 11 guests—to the Kentucky Derby on May 12, 1897. The Culbertsons had just moved into the gracious Georgian Revival home, which was designed by Minnesota architect William Channing Whitney. (Courtesy of Rudy van Meter and the Culbertson Mansion Bed and Breakfast.)

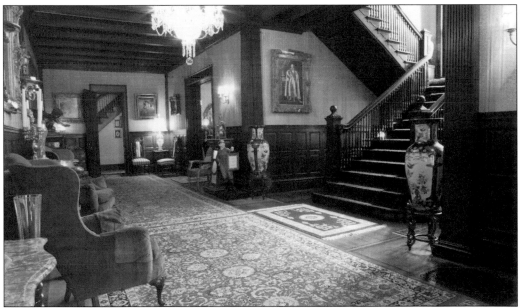

The massive reception hall of the Samuel Culbertson residence provides a glimpse of the Gilded Age grandeur that characterized the life of the gentry in Old Louisville. Off of the hall are a large formal drawing room, ladies' parlor, library, and dining room. Built in 1897 at a reported cost of $25,000, the mansion has dozens of rooms. Today it is a popular bed-and-breakfast inn. (Courtesy of Robert Pieroni.)

THE · LITTLE
COLONEL'S · HOLIDAYS

by

ANNIE · FELLOWS
JOHNSTON

The aristocracy of old Kentucky was brought to life in the stories of local author Annie Fellows Johnston, who in 1895 wrote *The Little Colonel*, the first of 13 semi-biographical novels that would sell millions of copies and be translated into over 40 languages. Samuel Culbertson's sons, William and Craig, would serve as the inspiration for the second book in the series, *Two Little Knights of Kentucky*.

William and Craig Culbertson, the real-life *Two Little Knights of Kentucky*, were featured on a series of postcards around 1900. Renamed Malcolm and Keith in the books, they were reoccurring characters for Annie Fellows Johnston. (Courtesy of Rudy van Meter and the Culbertson Mansion Bed and Breakfast.)

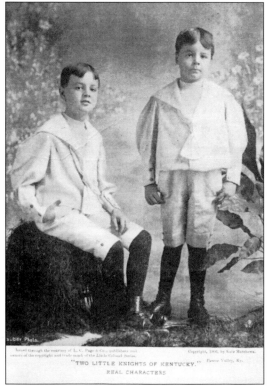

In true Gilded Age fashion, an impressive monument was erected at the end of Old Louisville's grandest thoroughfare, Third Avenue—or Millionaires Row—as it came to be known. Constructed in 1895, at a time when Louisville was increasingly identifying with the South, the Confederate Memorial was meant to honor Confederate soldiers who had died in the Civil War. A popular pastime in Victorian Louisville involved a weekend promenade down Third Avenue to the memorial and back. (University of Louisville Photographic Archives.)

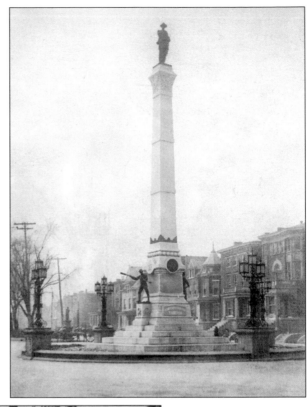

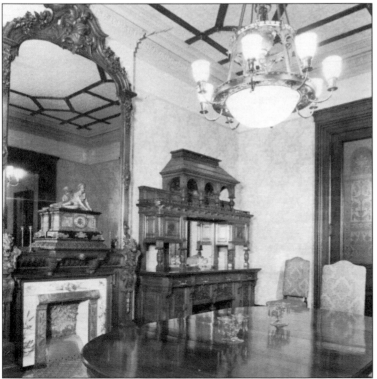

Louisville's foremost architect of the Gilded Age, Henry Whitestone, designed a number of Renaissance Revival- and Italianate-style residences for the elite of the city. One of them was the spacious mansion built for Joseph Tompkins at 851 South Fourth Street in 1871; the dining room was featured in an April 1974 edition of *Antiques* magazine. Today it is part of Spalding University. (Courtesy of Helga Photograph Studio and David Pearson.)

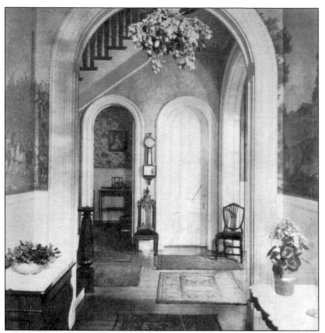

Another Italianate residence that survives from the 1870s is the home of Presbyterian minister John Cooke at 1348 South Third Street. Known for its elegant, hand-painted wallpaper, it was featured in the *Sunday Herald Post* on February 3, 1929, when it was home to Mr. and Mrs. John Engelhard. (Courtesy of the Estate of Polly and Clark Wood.)

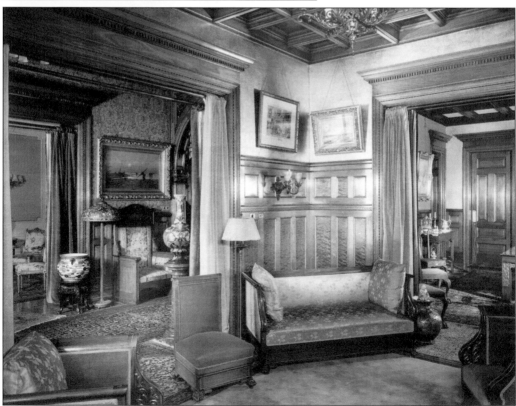

Elegant paneling and coffered ceilings round out a room that has all the trappings of Gilded Age domesticity: comfortable furniture, fine porcelain, stained glass, and artwork on the walls. The room is the study in the Third Street mansion of C. C. Mengel Jr. (Courtesy of Raymond Morgan.)

A southern view of the Mengel study shows a bank of built-in bookcases and an impressive fireplace with mosaic tile surround and carved wooden mantel. In addition to the Mengel family crest, the mantel includes decorative finials and imperial eagles. Beautiful woodwork abounds in the Mengel mansion, as in most Old Louisville homes, no doubt the result of Mengel's involvement in the lumber trade. (Courtesy of Raymond Morgan.)

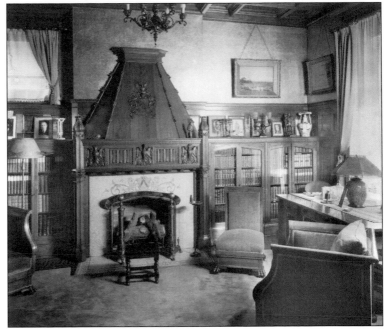

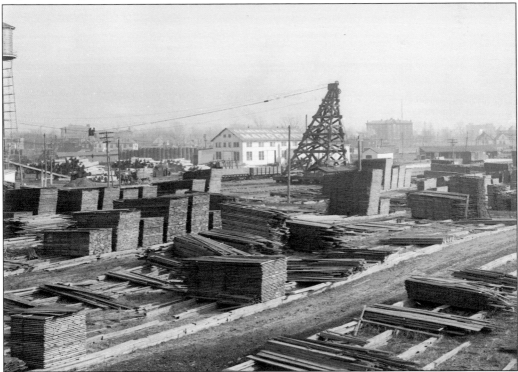

This is a 1907 photograph of the mahogany mills of C. C. Mengel and Brother Company. By 1899, the Mengels' 10-acre plant on Kentucky Street between Tenth and Twelfth Streets employed nearly 600 workers. Fifty million feet of lumber was processed here yearly. Both brothers took up residence on Third Street in Old Louisville. (Library of Congress, Prints and Photographs Division, Detroit Publishing Company Collection.)

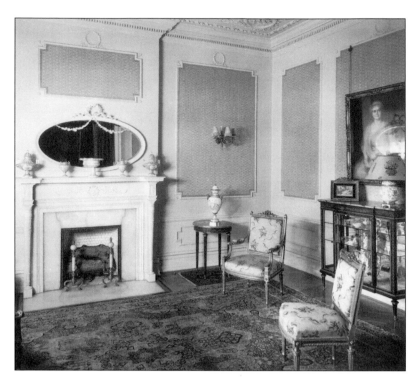

The woodwork has been painted in the ladies' parlor of the Mengel mansion, a common practice in Gilded Age America. Elaborate plaster ceilings crown the elegant space, which features gilt chairs and a framed portrait of Mrs. Mengel. This is the room where the lady of the house received female callers. (Courtesy of Raymond Morgan.)

Two servants look on in this photograph of the Mengel family dining room, taken in the early 1900s after the Gilded Age faded into the Edwardian era. The Edwardian period spans the reign of England's King Edward VII from 1901 to 1910 but frequently extends beyond his death in 1910 to include the years up to the sinking of the RMS *Titanic* in 1912, and even the end of World War I in 1918. (Courtesy of Raymond Morgan.)

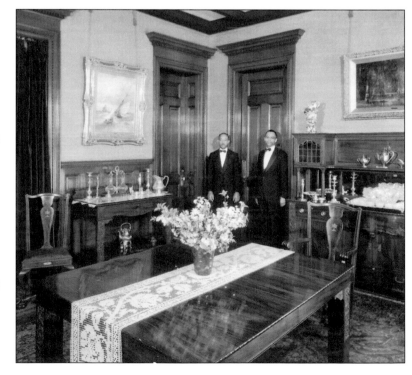

Among the grandest of Old Louisville mansions is the palatial residence at 1310 South Third Street. Completed in 1905 for oil refiner Edward Hite Ferguson, the Beaux-Arts masterpiece evoked images of grand Parisian homes and cost $100,000 in a neighborhood where the average dwelling cost $10,000. With its lavish interior features and mansard roof with ornamental balustrade, it counted as the most expensive home in the city and would come to symbolize the elegance of the Edwardian era in Kentucky. (Courtesy of Pearson's Funeral Home.)

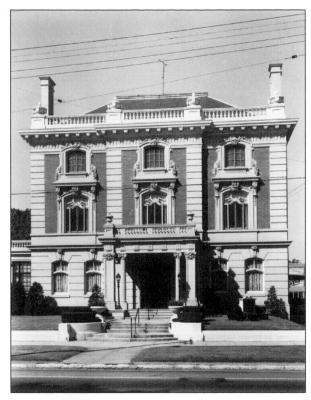

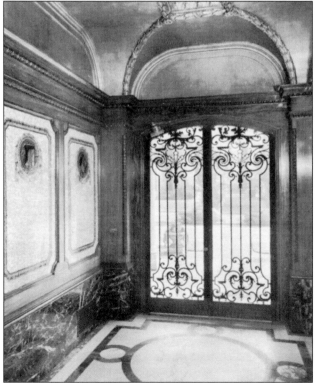

The entry hall of the Ferguson Mansion epitomizes the high level of craftsmanship still evident in the construction of Old Louisville homes at the beginning of the 20th century. A boveda ceiling towers over marble flooring and base panels, while recessed art glass sconces in walls covered with iridescent tile mosaics provide illumination. The Filson Historical Society has been headquartered in the building since 1986. (Courtesy of Pearson's Funeral Home.)

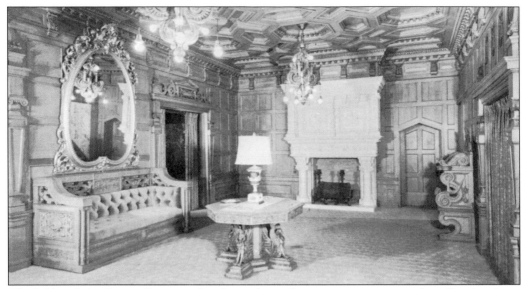

The lobby of the former Ferguson family residence features quarter-sawn oak coffered ceilings and rich wood paneling. A focal point is the massive stone mantel, hand-carved in France to commemorate the marriage of Edwin Hite Ferguson and Sophie Fullerton in 1898. Many of the mansion's original furnishings still remain, visual reminders of Edwardian elegance today. (Courtesy of Pearson's Funeral Home.)

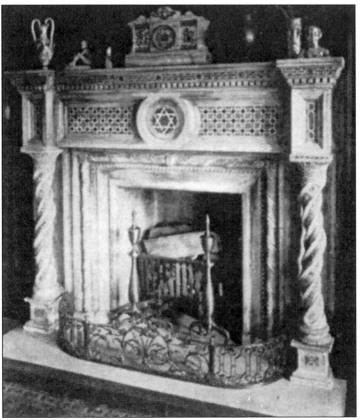

A close up of the fireplace mantel in the library of architect William J. Dodd shows the level of detail evident in so many of Old Louisville's Gilded Age and Edwardian mansions. With its Byzantine influences, the mantelpiece was the focal point of the architect's St. James Court residence, which was built in 1911. This photograph appeared in the 1912 catalogue for the Louisville chapter of the American Institute of Architects. (David Dominé Collection.)

Six

THE CALDWELLS OF LOUISVILLE, KENTUCKY

Among the Gilded Age families who would leave their mark on Old Louisville was the family of William Erwin Caldwell. An early photograph shows the patriarch of the family as a young man, at the onset of a career that would make him one of the wealthiest men in the city. (Courtesy of the Conrad-Caldwell House Museum.)

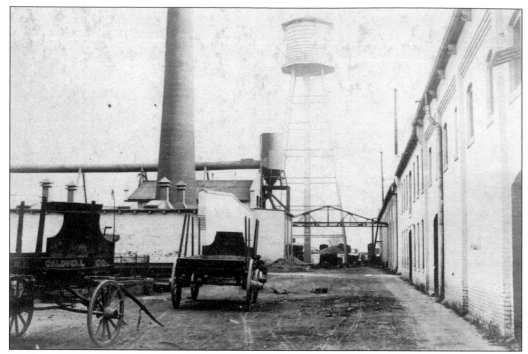

William Caldwell founded the W. E. Caldwell Company in 1887 to produce wooden tanks. Originally located on Main Street, the business soon started making distillery equipment and flour mill machinery and eventually added steel tanks to its lineup. The company would later relocate to the Old Louisville neighborhood, at a site near the corner of Brook and Brandeis. (Courtesy of the Caldwell family.)

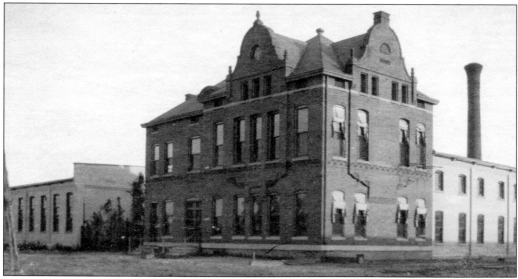

A photograph from about 1900 shows the main building of the W. E. Caldwell Company. Among the types of containers produced here were small pickle barrels, cadaver tanks for medical schools, and elevated water tanks with a capacity of half a million gallons. Holding a reported 8 million jiggers of water, Louisville's famous *Old Forester* bottle atop the Brown-Forman distillery is a Caldwell tank. (Courtesy of the Caldwell family.)

The Caldwell family residence can be seen in this picture from the family album. They lived in this Second Street home from the 1890s until they moved to St. James Court in 1905. Note the decorative brick inlay on the facade. (Courtesy of the Caldwell family.)

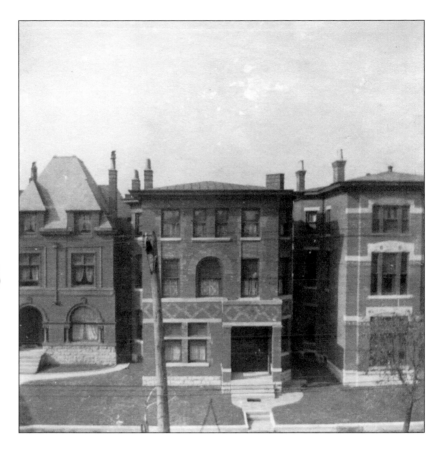

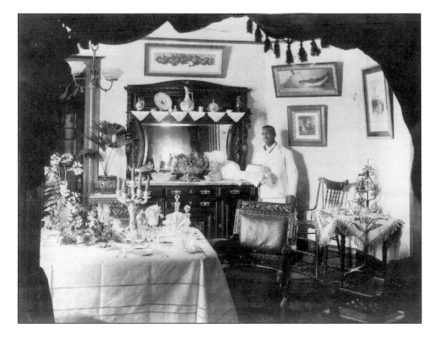

A servant stands offering a lovely dessert in the dining room of the Caldwells' residence on the 1200 block of South Second Street. A lavishly set table greeted the family for both lunch and dinner. (Courtesy of the Caldwell family.)

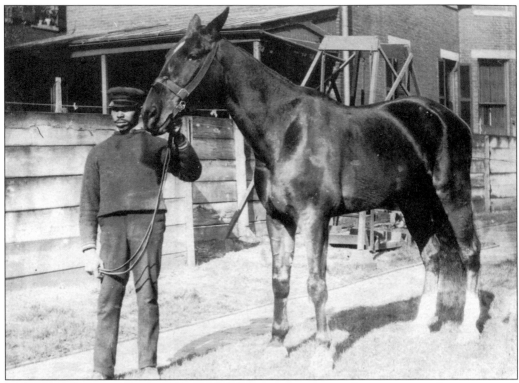

In the 1890s, horses and mules still provided the main power source for most means of transportation in the country. Until the early 1900s, homes for the well-to-do in Louisville were built with carriage houses in the rear for horses and buggies. In this photograph, another Caldwell servant attends to the family's beast of burden. (Courtesy of the Caldwell family.)

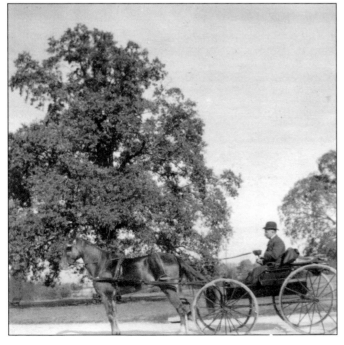

Hitched up and ready to go in his trademark derby hat, William Caldwell prepares for a buggy ride around the park. The photograph was taken by Caldwell's son, Walter, around 1895. (Courtesy of the Caldwell family.)

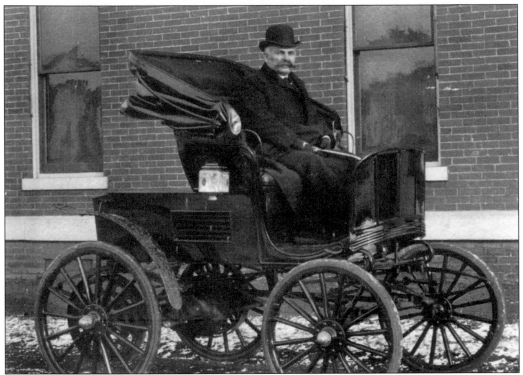

Still in his derby hat, William Caldwell had progressed to a horseless carriage by the time this photograph was snapped outside the family business in 1903. Walter Caldwell, his son, was the amateur photographer who shot this picture and many others of the Old Louisville neighborhood. (Courtesy of the Caldwell family.)

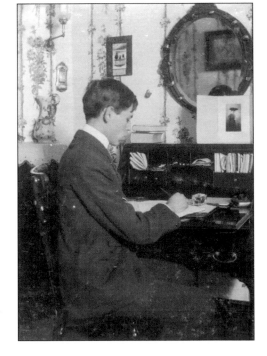

Who took this photograph is unidentified, as the normal photographer is the subject of the picture. Seen working at his desk in his room at the Second Street home, Walter Caldwell would eventually take over as president of the family's company. (Courtesy of the Caldwell family.)

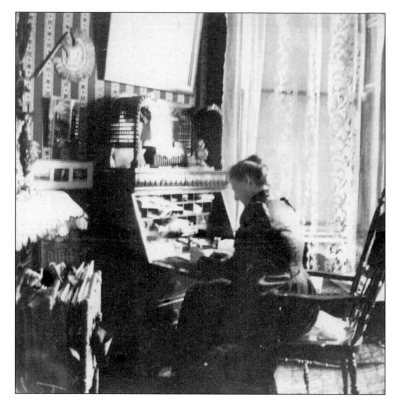

The life of a Victorian lady of the upper classes was not all fun and play. Even though servants were on hand for menial chores, the task of running a household usually fell to the lady of the house and required considerable planning. In this picture, the photographer's mother is seen working at her desk. (Courtesy of the Caldwell family.)

A photograph from the late 1800s shows cadet Walter Caldwell, who, as an adolescent, was educated at Wentworth Military Academy in Lexington, Missouri. It was not uncommon for well-to-do Louisvillians to send their children off for formal education at boarding schools and military academies in other states. (Courtesy of the Conrad-Caldwell House Museum.)

Walter's sister, Grace, can be seen in this early photographic portrait. Some of her possessions, such as a treasured doll and miniature furniture pieces, are on display in her room at the Conrad-Caldwell House Museum on St. James Court. The Caldwells purchased the former residence of Theophilus Conrad after his death in 1905 and moved here from their Second Street home. (Courtesy of the Conrad-Caldwell House Museum.)

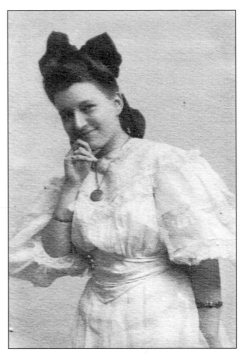

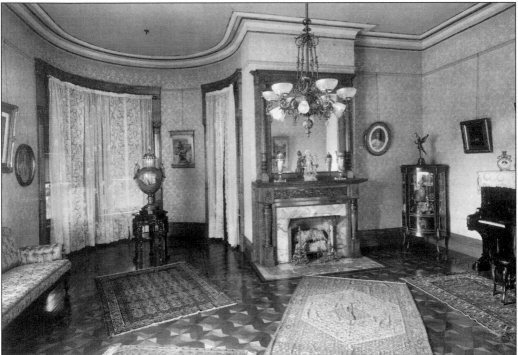

At the Conrad-Caldwell House Museum at 1402 St. James Court, an oil painting of Grace Caldwell hangs in the ladies parlor today. This photograph from around 1908 shows how the room looked shortly before Mrs. William Caldwell had the interior of the house redesigned. Visible in the picture is a stunning parquet floor mimicking American quilt patterns. (Courtesy of the Conrad-Caldwell House Museum.)

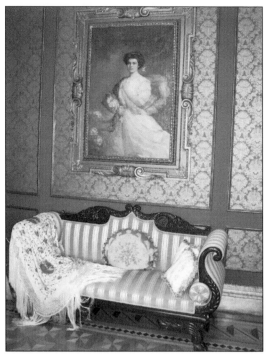

An artist's rendering, as seen in the ladies parlor of the Conrad-Caldwell House Museum, shows Grace Caldwell as a young woman. The former residence of the Conrad and Caldwell families is the only house museum open for tours in the neighborhood today. (David Dominé Collection.)

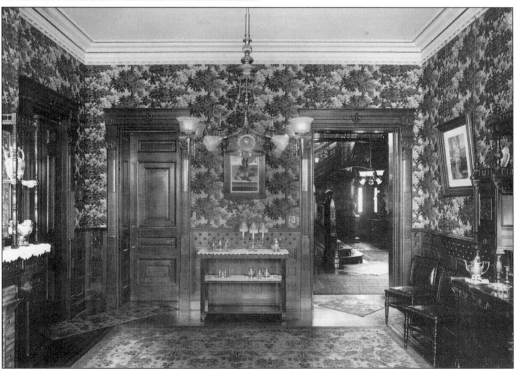

A photograph from the first decade of the 1900s shows a view of the dining room in the Caldwell's new home, the former residence of Theophilus Conrad. Family artifacts and period antiques are on display today, providing a rare glimpse of life for an upper-class Victorian family. (Courtesy of the Conrad-Caldwell House Museum.)

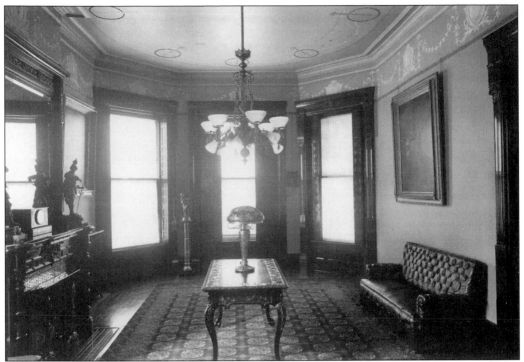

Another photograph from the very early 1900s shows the first-floor library of the Caldwell residence. In addition to artwork on the walls, a mantel clock, bronze sculptures, and an Art Nouveau lamp enhance the interior decor. (Courtesy of the Conrad-Caldwell House Museum.)

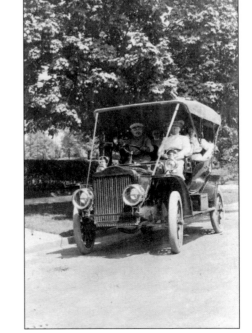

Always the one to keep abreast of modern technology, William Caldwell was one of the first residents of Old Louisville to own an automobile. Every few years, he would get the latest model. In this photograph taken by his son around 1906, William Caldwell can be seen at the wheel of a new roadster. (Courtesy of the Caldwell family.)

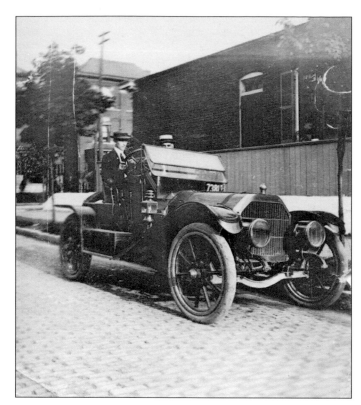

Several years later, William Caldwell moved on to a newer model car, as seen in this photograph taken on August 15, 1912, near the corner of Second and Brandeis Streets. As his style of vehicle progressed, so did the type of hat he wore, as evidenced by the straw boater he sports in the photograph. (Courtesy of the Caldwell family.)

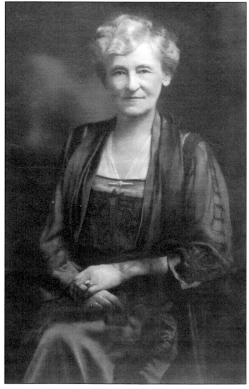

Family members believe Elaine Antoinette "Netty" Caldwell, the wife of William Caldwell, sat for this photograph sometime in the early 1920s. Remembered by friends and neighbors for her fashionable entertaining and sense of style, the matriarch of the Caldwell family died on April 22, 1925. (Courtesy of the Conrad-Caldwell House Museum.)

In his later years, William Caldwell gave control of the family business to his son Walter and devoted himself to the enjoyment of life on St. James Court. A photograph from about 1924 shows him in front of the family home with grandson Gordon. (Courtesy of the Conrad-Caldwell House Museum.)

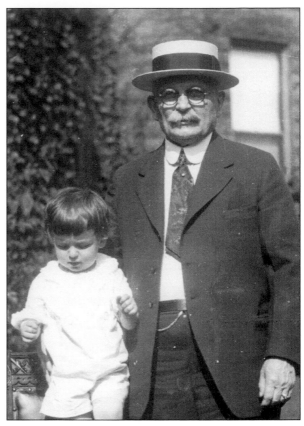

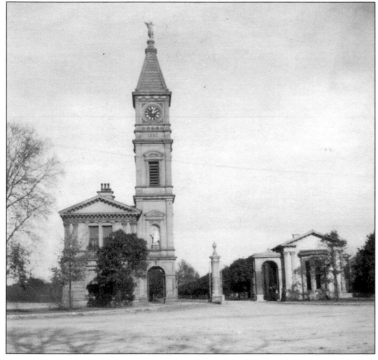

Like many of the middle- and upper-class residents of Old Louisville, William E. Caldwell and his wife, Elaine Antoinette, would be buried at Cave Hill Cemetery at 701 Baxter Avenue. The cemetery, known for its impressive number of Corinthian and Victorian monuments, was placed on the National Register of Historic Places in 1979. (Courtesy of the Caldwell family.)

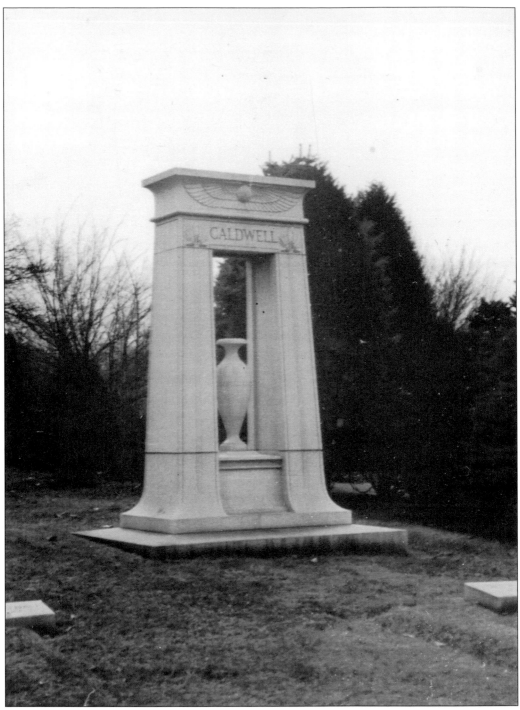

Located in section 22, lot 208, of Cave Hill Cemetery is the Caldwell family monument, which was erected in the 1920s after the death of Elaine Caldwell. William Caldwell was interred here after his death in 1938. The top of the monument is adorned with a winged globe, a symbol with Egyptian origins that represents the perfected soul returning to the source of creation in the Elysian Fields. (Courtesy of the Caldwell family.)

Seven

A LIFE OF LEISURE

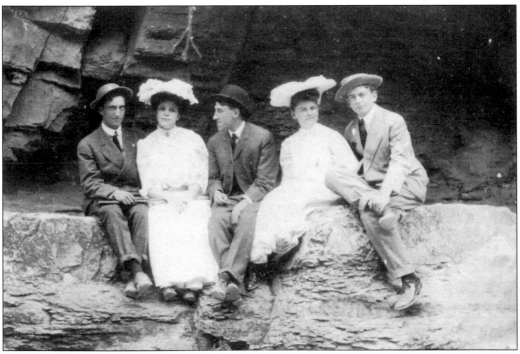

At the turn of the 20th century, members of the leisure class of Old Louisville had many ways in which to enjoy themselves. Travel, boating, horse races, and even amateur photography filled their free hours with pleasure. Young Walter Caldwell pursued his hobby, photography, with a passion. It is thanks to him that many of these photographs exist. Pictured here, what appears to be two couples and a fifth wheel, members of Walter's "social club," enjoy an outing. (Courtesy of the Caldwell family.)

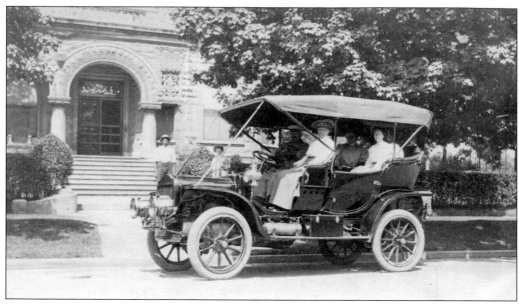

Back when the automobile was still a novelty, the leisure class would load up in the family flivver for a pleasant ride in the country. Here the Caldwells ready themselves for a pleasant summer's drive through the countryside in their 1906 REO. Mr. Caldwell's servant Henry stands on the sidewalk, a little lost with nothing to do. In the old days, he would have hitched the team to the carriage and brought it around to the front. (Courtesy of the Caldwell family.)

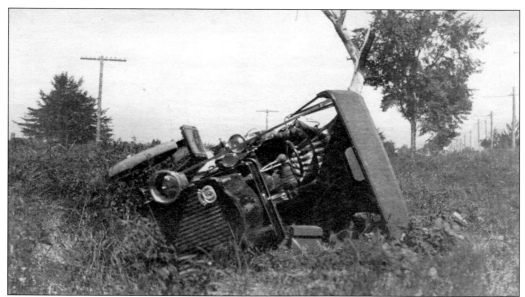

Oops! This photograph is the next one in the Caldwell family album. Perhaps something went a bit awry. Early on in the 20th century, automobiles often frightened horses with their noise and exhaust and there were often terrific conflicts on the roadways. The car appears to be some distance from the road (marked by the line of telephone poles on the right). One can only imagine what happened this day. (Courtesy of the Caldwell family.)

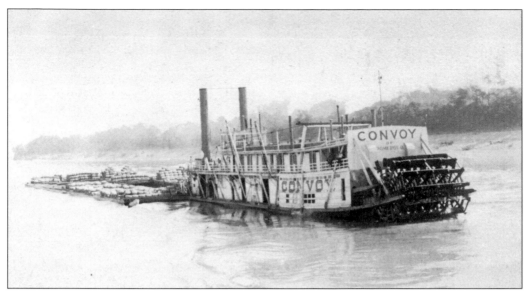

In 1903, Walter Caldwell photographed this steamboat, the *Convoy* of Pomeroy, Ohio, pushing a barge of goods up the Ohio River. Walter and his wife, Gertrude, traveled extensively. They made a point of attending every exposition and world's fair. They also enjoyed sightseeing in Chicago on trips to visit Gertrude's family in Oshkosh, Wisconsin. Judging from the angle of the shot, Walter took this picture from another boat while on a river excursion. (Courtesy of the Caldwell family.)

On the same 1903 voyage, Walter Caldwell took this picture of the Louisville Waterworks pumping station No. 1 at 3005 River Road. Since the W. E. Caldwell Company made water tanks and towers, this was of particular interest to Walter. Today it is the only surviving station in the United States (out of four) designed by engineer Theodore R. Scowdon. Note the rows of plantings on the left. The fertile bottomland along the river was excellent for crop production. (Courtesy of the Caldwell family.)

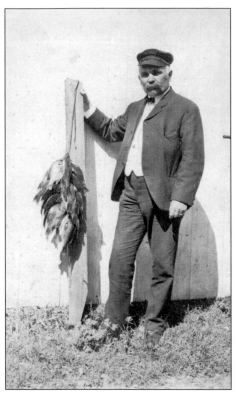

William E. Caldwell stands proudly beside a single day's catch. The family enjoyed fishing and had a lakeside camp at Sunset Point in Oshkosh, Wisconsin. It was a favorite vacation spot, and the Caldwells returned there quite often. The family still goes there on occasion to this day. This picture is believed to have been taken around 1910. (Courtesy of the Caldwell family.)

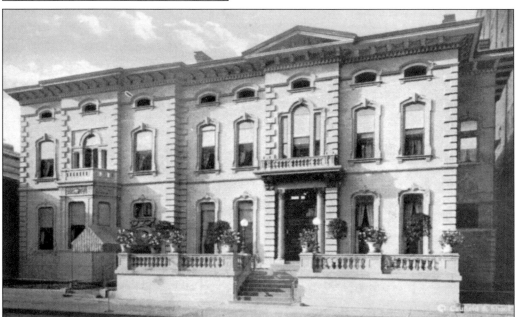

Another favorite activity of gentlemen of the leisure class was spending time at their clubs. The Pendennis Club, located in the former Belknap Mansion on Walnut Street (now Muhammad Ali) between Third and Fourth Streets, was the club of choice for William and Walter Caldwell. The name, which comes from Thackeray's *History of Pendennis,* has a Cornish derivation meaning "high place." (Ronald Harris Collection.)

Although there is no evidence that the Caldwell men were members of the Elks club, Walter did take his camera to this Elks-sponsored carnival in 1893. It included booths for Engelhard and Sons Roast Coffee and Superior Quality Grand March Cigars. (Courtesy of the Caldwell family.)

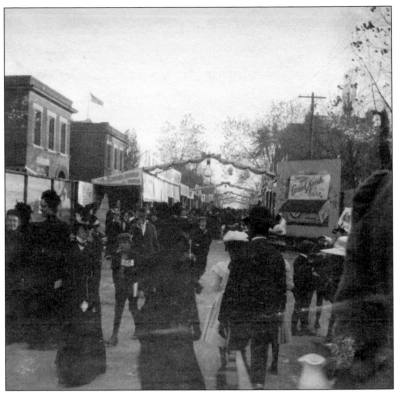

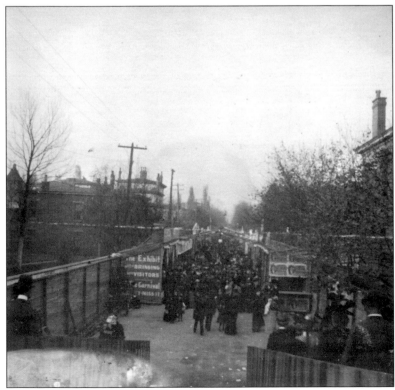

In this view of the Elks fair, a teaser sign on the left touts, "The exhibit here is bringing many visitors to the carnival. Don't Miss it." The Benevolent and Protective Order of Elks was founded by a group of entertainers and actors in New York City in 1868. First named "the Jolly Corks," the charitable order continues its good works today. (Courtesy of the Caldwell family.)

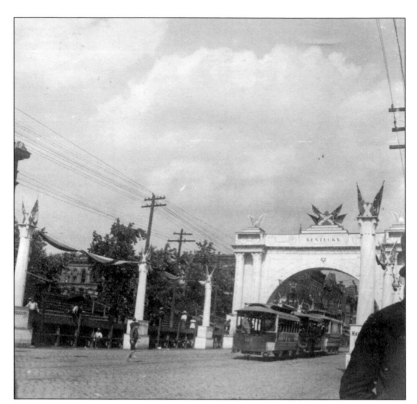

In 1901, the Grand Army of the Republic, an organization of Union Civil War Veterans, held its annual encampment in Chicago. The highlight was a magnificent Grand Court of Honor, which extended a mile along Michigan Avenue. Walter Caldwell was there, camera in tow, and took this photograph of the Kentucky archway. (Courtesy of the Caldwell family.)

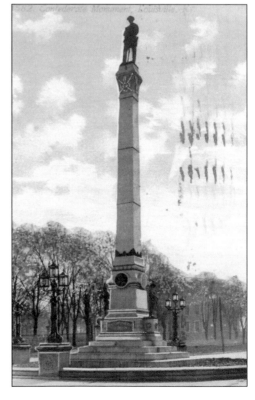

In the evenings, after the workday, residents of Millionaires Row took to the expansive walkways of Third Street (then called Third Avenue) to promenade down to the circle at Confederate Place and back. This area has been reconfigured numerous times through the years, but the monument itself has declined in condition, a hapless victim of its own political incorrectness. In this early postcard view, the Speed museum has not yet been built. (Ronald Harris Collection.)

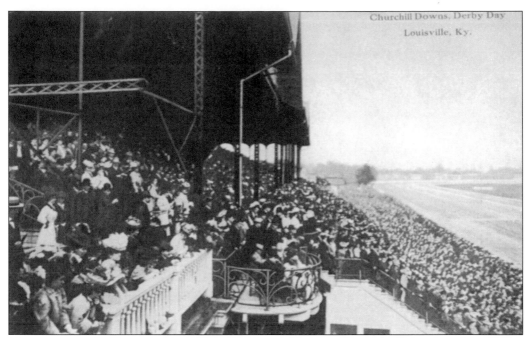

Horse racing—the Kentucky Derby in particular—has always been part of the play of the leisure class of Old Louisville. The owners of two Derby winners lived in Old Louisville. Beverly P. Grigsby, owner of Azra, the 1892 winner, lived at 1366 South Third Street. H. C. Applegate, a whiskey magnate and the owner of Old Rosebud, the 1914 winner, lived at 1234 South Third Street. Applegate's horse had been named after his product, Old Rosebud Bourbon. (Ronald Harris Collection.)

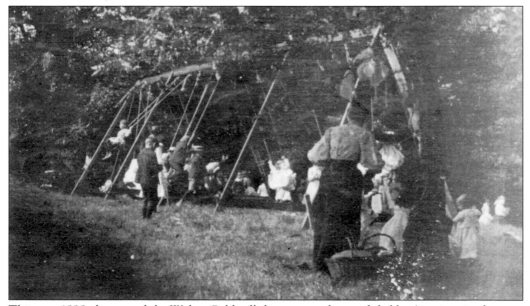

This rare 1898 photograph by Walter Caldwell shows an early set of children's swings in the area that would officially become Central Park in 1905. For these children of the leisure class, life was good indeed. Note the nanny with the picnic basket in the right foreground. (Courtesy of the Caldwell family.)

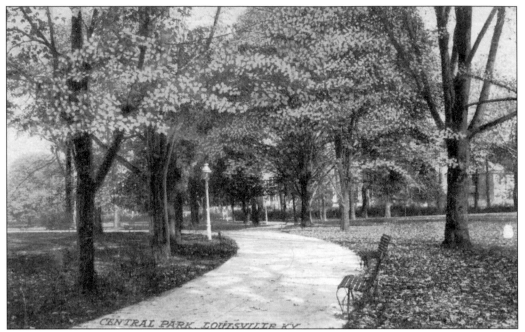

In this 1907 northwestern view of Central Park, wide promenades arc gracefully through the terrain. Trees cast their dappled shadows on the recently poured cement. Through the trees, glimpses of the mansions along Park Avenue can be seen. The park was designed by the firm of Frederick law Olmsted, designer of New York City's Central Park. (Courtesy of Charlene Claycomb.)

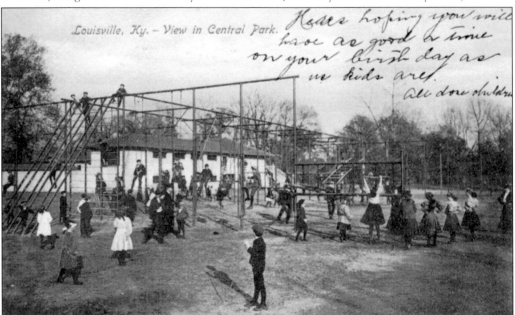

In these days of safety and liability issues, this playground in Central Park would be the subject of irate consumer advocates and liability lawsuits. Note the height of the monkey bars and the absence of rubber padding. This was a time when children learned the hard way—even children of the privileged. The view is from a photo postcard dated August 5, 1906, a year after the park opened. (Ronald Harris Collection.)

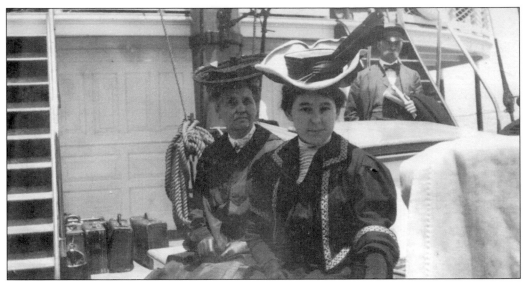

In this 1915 photograph, Walter Caldwell's future wife, Gertrude Brownell (right foreground), and her mother, Belle (left), sit on the deck of a steamer on route to Catalina Island. Belle Brownell was a milliner by trade—thus the wonderful hats the ladies are wearing. The gentleman in the background, taking a great interest in the proceedings, is an unidentified fellow passenger. (Courtesy of the Caldwell family.)

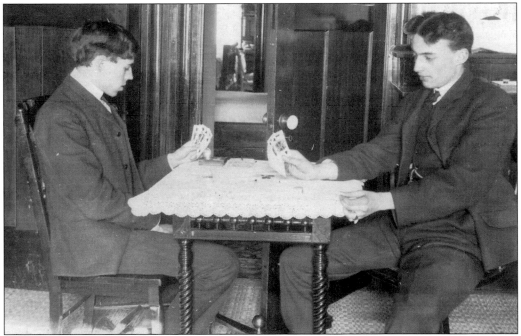

Walter Caldwell (left) and friend Douglas Barkley enjoy a game of poker in the Caldwell's Second Street house. Games of chance were a common pastime of the leisure class. In fact, the Pink Palace on St. James Court began its life as the St. James Court Gentleman's Club or "the Casino." At the club, local bigwigs could sit at ease while enjoying their bourbon and cigars, diverting themselves with the occasional hand of poker and plenty of neighborhood gossip. (Courtesy of the Caldwell family.)

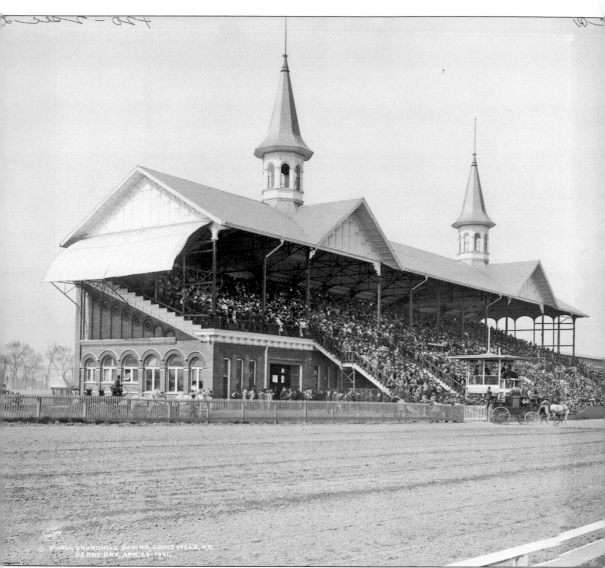

In this panorama of Churchill Downs on Derby Day, April 29, 1901, it appears that the track is doing a land office business. Nothing could be further from the truth. In its first 27 years, the track never made a profit. Finally on October 1, 1902, a group headed by the mayor of Louisville, Charles F. Grainger (a St. James Court resident), took over the operation of Churchill Downs. Under this new administration, the track finally showed its first profit in 1903, twenty-eight years

DETROIT PHOTOGRAPHIC CO.

after its founding. Under Grainger's stewardship, the purse for the Kentucky Derby increased from $5,000 to $50,000 by 1918. On this Derby Day, the winner was His Eminence, ridden by jockey Jimmy Winkfield, in a time of 2:07. (Library of Congress, Prints and Photographs Division, Detroit Publishing Company Collection.)

In Walter Caldwell's first photograph album there are upwards of 15 pictures identified simply as "Rachel Graves." Who was this young woman with the Mona Lisa smile? It is known that she was a member of Walter Caldwell's social club and was probably a neighbor when the family lived on Second Street. The trail grows cold there. Walter, it is said, had quite a way with the ladies. (Courtesy of the Caldwell family.)

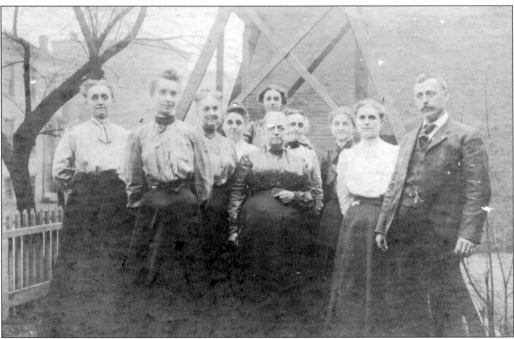

Old Louisville families would often engage a photography studio to come to their home and take pictures. Posing in their side yard at 522 West Breckinridge are a matriarch, many great aunts, and one great uncle of Robert B. Lawfer Jr. On the carded back of the photograph, everyone has been dutifully identified. They are, from left to right, aunt Sudu, aunt Betty, aunt Fannie, aunt Mattie, grandma Melone, aunt Grace, aunt Agnes, Lucy, aunt Pearl, and uncle Chester. (Courtesy of Norma and Robert Laufer Jr.)

Eight

THE OTHER OLD LOUISVILLE

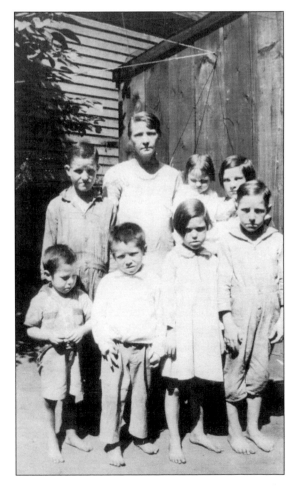

Two blocks from the opulence of St. James Court, literally on the other side of the tracks, poor families such as this one lived in abject poverty in whatever sort of homes they could cobble together. The area was largely the grounds of an abandoned racetrack—the old Oakland Race Course. Because truck farmers grew cabbages nearby, locals soon began referring to the area as "the Cabbage Patch." (Courtesy of Cabbage Patch Settlement Archives.)

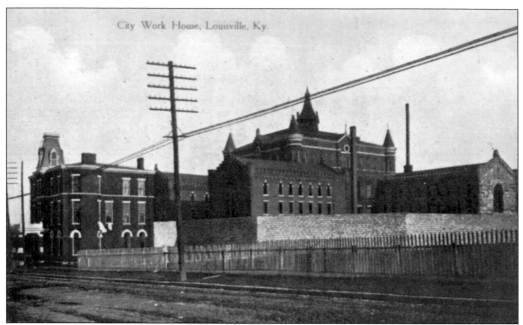

City Work House, Louisville, Ky.

Two bleak alternatives to the Cabbage Patch are depicted here. The City Workhouse (above) was originally intended for misdemeanor offenders but soon began to accommodate the poor and sick as well. Individuals who did not (or could not) pay fines were allowed to work them off through their labors. Located at the corner of Payne Street and Lexington Road, the workhouse contained a quarry and brick-making facility. Inmates worked from sunup to sundown paying for their room and board by breaking rocks, making bricks, and gardening. The Home for the Aged and Infirm (below) opened in 1874. Residents earned their keep by sewing, cooking, or helping with the gardening. The property was surrounded by a farm that was also worked by prisoners from the city workhouse. (Both courtesy Ronald Harris Collection.)

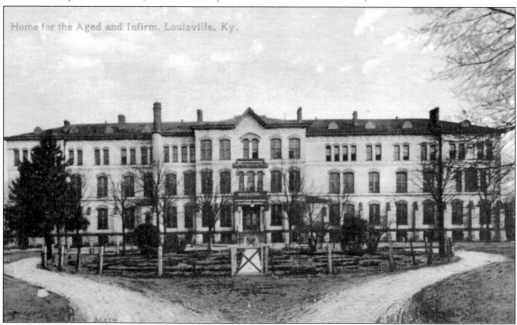

Home for the Aged and Infirm, Louisville, Ky.

Depicted is the cover of a 1901 first edition of *Mrs. Wiggs of the Cabbage Patch*, the book read 'round the globe. This heartwarming story of an optimistic widow raising five children in the poverty of the Cabbage Patch made the area famous the world over. The novel was a best seller for two years and was translated into Spanish, Norwegian, Danish, Japanese, French, and Braille. It sold more than 650,000 copies in the first year. (David Dominé Collection.)

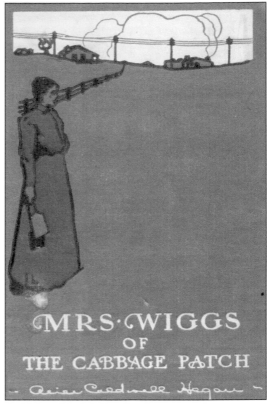

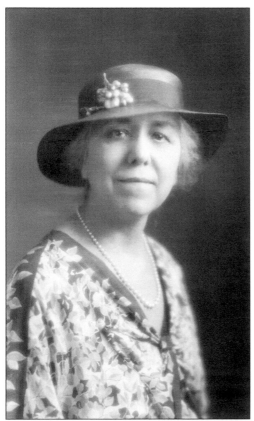

A photographic image captures Old Louisville author Alice Caldwell Hegan, as she appeared in later years. While doing volunteer social work in the desperately poor Cabbage Patch neighborhood, Hegan met a resident named Mary Bass, a woman who served as her inspiration for the character of Mrs. Wiggs. In December 1902, Hegan married Louisville poet, playwright, and philosopher Cale Young Rice. (Courtesy of University of Louisville Photographic Archives.)

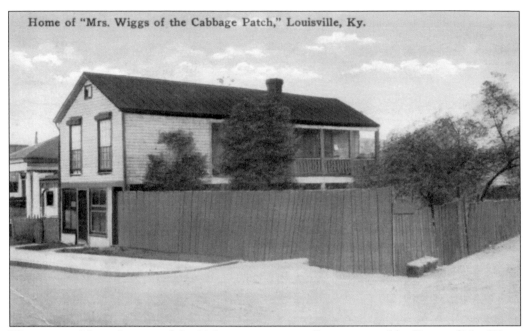

Home of "Mrs. Wiggs of the Cabbage Patch," Louisville, Ky.

This postcard from the turn of the 20th century supposedly represents "the Home of Mrs. Wiggs of the Cabbage Patch, Louisville, Kentucky." It speaks of the vast popularity of Hegan's novel that a postcard was made and marketed. Local historians have tried in vain to pinpoint this exact location, to no avail. Many speculate that it is a site somewhere along Magnolia Avenue, perhaps between Sixth and Seventh Streets. (Ronald Harris Collection.)

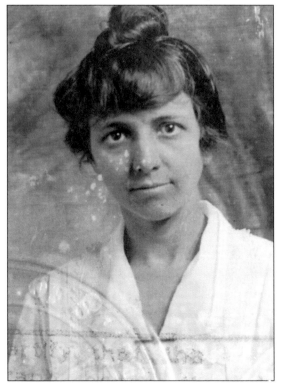

Louise Marshall is pictured in this rare 1915 passport photograph taken five years after she established the Cabbage Patch Settlement House. Her work began through the Stuart Robinson Memorial Presbyterian Church. Quoting Ms. Marshall: "There was an old saloon and dance hall on the corner of Seventh and Jarvis. They were going to try to have an extension there for Sunday school. We called it People's Hall." (Courtesy of Cabbage Patch Settlement Archives.)

EIGHTH ANNUAL REPORT OF THE

Cabbage Patch Settlement House

1461 NINTH STREET

Endorsed by the Charities Endorsement Committee

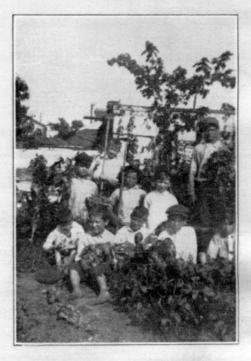

DIRECTORS:

MISS LOUISE MARSHALL, President
MRS. CALE YOUNG RICE, Vice Pres.
MRS MARY H. TARRY, Secy. and Treas.
MRS THEODORE WINTERSMITH
MRS. AUGUST SCHACHNER
MISS NANCY LEE FRAYSER

1919

Poor children pose in a yard garden in this rare glimpse of life in the Cabbage Patch on the cover of the 1919 annual report for the Cabbage Patch Settlement House. In 1910, Miss Marshall and her friends had decided to establish a settlement house, a popular way to help people in poor neighborhoods at the turn of the 20th century. A settlement house was staffed by resident workers and offered a variety of programs to help people in the neighborhood help themselves. To quote their mission statement: "Our mission is to serve those of our community in need, in the spirit of Christian Love (as exemplified by the Gospel of Matthew 25:35-40). These needs include: the spiritual, physical, social, emotional, moral and educational." By the time of this report, Louise Marshall and Alice Caldwell Hegan had joined forces. Listed here under her married name, Mrs. Alice Hegan Rice, the author now served as vice president of the organization. (Courtesy of Cabbage Patch Settlement Archives.)

Ninth and Hill Settlement
Formerly
Cabbage Patch Settlement House
1461 NINTH STREET
LOUISVILLE - - KENTUCKY
Endorsed by the Charities Endorsement Committee

Present Inadequate Building

DIRECTORS:

MISS LOUISE MARSHALL, President
MRS. CALE YOUNG RICE, Vice President
MRS. CHARLES CASTNER, Secretary
MRS. MARY H. TARRY, Treasurer
MR. and MRS. R. S. REYNOLDS
MRS. JOHN D. WAKEFIELD
MRS. THEODORE WINTERSMITH
MRS. HENRY C. COLGAN
MRS. J. HARDIN WARD
MRS. FRANK THOMPSON
DR. CHARLES H. PRATT
MR. HUGH FLEECE

1927

By 1927, the settlement house had outgrown its original headquarters at 1461 Ninth Street, featuring the structure on the cover of its annual report with the caption "present inadequate building." Back in August 1910, Miss Marshall and her friends had begun seeking donations for this building. In October of that year, they became a not-for-profit corporation, naming the planned new facility the Cabbage Patch Settlement House. The building was designed by E. T. Hutchins, a local architect and friend of Miss Marshall's. There was just one room and a closet on the first floor. At the back of the house, a staircase led to the second floor where there were children's and adult libraries as well as living quarters for resident workers. This small building served as a hub of social activity and betterment for the Cabbage Patch community until January 1930 and the dedication of the new building. (Courtesy of Cabbage Patch Settlement Archives.)

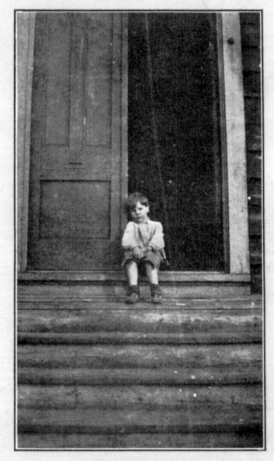

Cabbage Patch Settlememt House

1413 SOUTH SIXTH STREET
LOUISVILLE · · KENTUCKY

Endorsed by the Charities Endorsement Committee

Waiting for Your Help

1930

"Waiting for your help" is the caption under this touching photograph of a wistful little boy sitting on the ramshackle steps of a Cabbage Patch dwelling. By the early 1930s, the settlement house was in a new headquarters at 1413 South Sixth Street. This new space was sorely needed. Attendance had grown from 9,000 a year in 1914 to 18,461 by 1925. According to the 1929–1930 annual report: "The new home for which we have worked so long is now a reality. A big, new modern gymnasium and two substantial brick buildings on Sixth Street, south of Magnolia Avenue are already overflowing, not only with our old boys and girls, but with many new ones from the factory sections to the southwest." During the first year in this new location, the settlement offered recreation, a free clinic, library service, domestic training, and Christian education to over 1,600 individuals at a cost of less than $4 per capita. (Courtesy of Cabbage Patch Settlement Archives.)

Girls

Green Peppers (15-19 years)
Athletics, Dramatics, Handiwork

Girl's Athletic Club (12-15 years)
Athletics and Dramatics

**Girl Scouts
(10-15 years)**

**Cooking
(2 groups)
(8-14 years)**

**Sewing School
(8-14 years)**

**Piano Lessons
(8-13 years)**

**Primary Club
(6-9 years)**

Little Children

Story Hour
(3 times a week)

Kindergarten

Baby Clinic
Keeping Well Babies Well

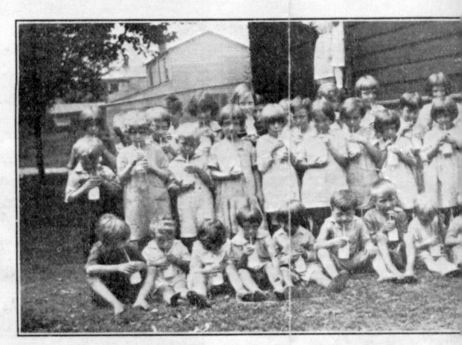

Daily Vacation Bible School
Summer of 1930 — Enrollment 205

You

Ga

Fri
Atl

P

Adults

…en's Social Club

…Athletic Club

…Women's Club

…Women's Athletic Club

…mmunity Night
…vening of Fun

Library
Twice a Week

Rummage Sale
Putting Necessities of
Life Within the Reach
of Our People

Boys

Shamrocks
(16-20 years)
Hygiene, Politics,
Health Examinations

Athletic Club
(15-18 years)

Athletic Club
(12-15 years)

Newsboys' Club
(12-14 years)

…Room — Table Games

…Indians (9-12 years)
…s, Educational Program

…y Group (6-9 years)

…rgarten (3-6 years)

The centerfold of the 1930 annual report detailing the many programs the settlement offered at that time to uplift the poor. Quoting again from the settlement's mission statement: "Our philosophy is to enrich the lives of the individuals we serve; to enable them to encounter the challenges of their lives with hope; to provide those we serve with the skills, knowledge and disciplines to build their own lives productively and creatively." It is indeed a tribute to Louise Marshall that so many rose from poverty and built successful lives with the tools she and the settlement made available to them. (Courtesy of Cabbage Patch Settlement Archives.)

269 Babies in the Baby Clinic

To the Sustaining Members

The new home for which we have worked so long is now a reality. A big, new, modern gymnasium and two substantial brick buildings on

332 Boys and 100 Men Attended Settlement Groups in 1930

This insert page from the 1930 report stresses the settlement's baby clinic and gymnasium. Infant mortality was quite high in the area prior to the settlement's work. Families were so poor in the Cabbage Patch that often when a child died, there was no money for funeral expenses. The child was sometimes laid to rest in a corner of the family's yard. Since there was no man on staff to work with the boys, Louise Marshall herself coached the young men in basketball and baseball. Every Sunday, Marshall would engage a truck to take them wherever they were scheduled to play ball, and the little towns would pay the settlement's expenses. The team played throughout Jefferson and Bullitt counties. During the game a long, pointed hat would be passed through the crowd to take up a collection for their expenses. (Courtesy of Cabbage Patch Settlement Archives.)

The staggering need is evident in this moving photograph from the back of the 1930 annual report. Almost no homes in the Cabbage Patch had a bathtub. A fixture in the neighborhood was the public bathhouse at 1536 South Seventh Street. It had two shower rooms: one for males and one for females. Everyone brought his or her own soap, wrapped up in a towel. (Courtesy of Cabbage Patch Settlement Archives.)

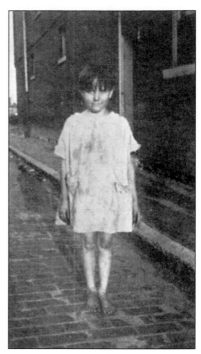

This photograph shows the Cabbage Patch Settlement House as it looks today. The organization has grown into a set of interconnected houses and even managed to add 19,000 square feet to the complex recently while retaining the look and feel of the original neighborhood. A structure added to alley frontage was even designed as a carriage house to emulate surrounding landmark architecture. Many residents think the Cabbage Patch is one of Old Louisville's finest neighbors. (Ronald Harris Collection.)

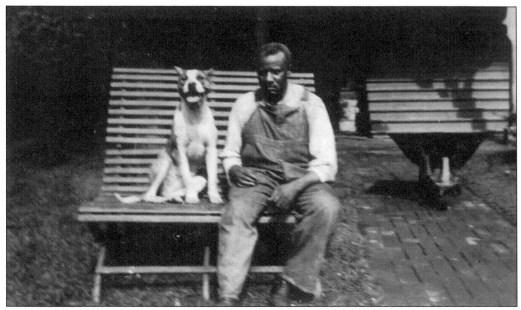

In the stables, kitchens, and nurseries of Old Louisville, another facet of society made their living. Servants, many of them African Americans from the adjacent Black Hill area, tended to the wealthy by cooking their meals, stabling their horses, and raising their children. Here Henry, an employee of the William Caldwell family, is pictured with the family dog. Henry was an indispensable part of the household. (Courtesy of the Caldwell family.)

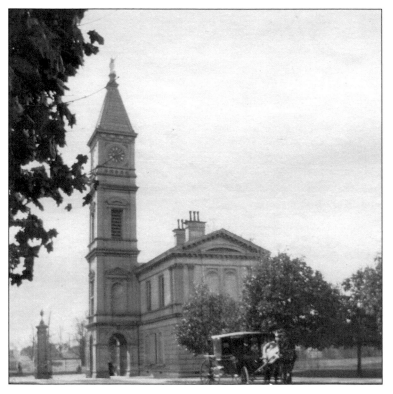

While the poor of the Cabbage patch often resorted to the burial of a child in a corner of the yard, the mourning of the wealthy was softened by this magnificent Corinthian-style entrance to Cave Hill Cemetery. Designed by architect William H. Redin, it includes a 2,000-pound bell and a clock tower. Legions of Old Louisville residents are interred there. (Courtesy of the Caldwell family.)

Nine

DECADES OF DISASTER

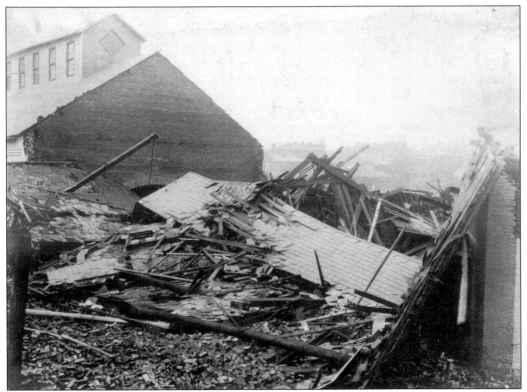

Old Louisville has seen its share of disasters. Tornados, fires, ice storms, blizzards, earthquakes, and floods have all visited the stately Victorians of the area through the years. On the night of Thursday, March 27, 1890, the city of Louisville experienced the worst tornado in its history, however random twisters and windstorms would wreak havoc throughout the decades. The W. E. Caldwell Company was one establishment that suffered. It is assumed that Caldwell's son Walter, an Old Louisville resident and amateur photographer, took this photograph of the devastation. (Courtesy of the Caldwell family.)

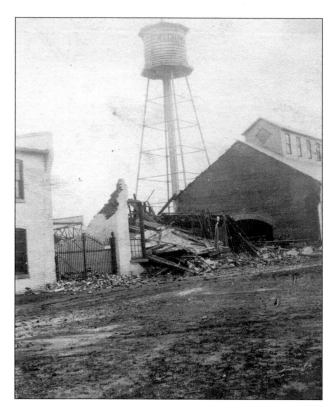

The W. E. Caldwell Company made water tower tanks. It is ironic that in this second shot taken by Walter Caldwell, the company's water tower stands proudly intact in the midst of the wreckage. The company was founded in 1887 near the corner of Second and Brandeis Streets. (Courtesy of the Caldwell family.)

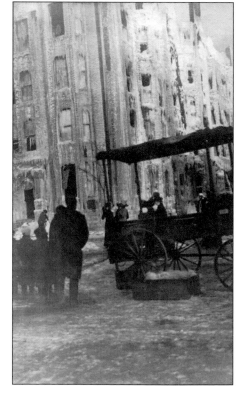

On a frigid February day in 1912, a fire broke out in the St. James Apartments, a six-story structure on St. James Court. Walter Caldwell grabbed his camera and walked over to record the aftermath. Because of the 8-degree temperature, the building was completely swathed in ice. A number of children and several ladies in fine hats survey the scene. A female Red Cross worker stands behind the wagon in the white headdress. (Courtesy of the Caldwell family.)

Although a double exposure by an excited amateur photographer, this rare shot of the St. James Apartments fire clearly shows the lacework of ice that formed on the fire escape that frosty, 8-degree morning. Extensively damaged, the top floors were removed by the owners, making the building three stories. Court residents were pleased; for years, they had hated the towering multi-story structure. Now it fit properly into a three-story neighborhood! (Courtesy of the Caldwell family.)

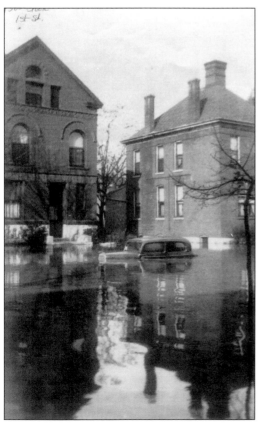

In January 1937, one of the largest floods in American history occurred in Louisville. Heavy rain fell from January 9 until January 17. After that, a second wave came from January 17 until January 23. The river crested at 51.1 feet. Adding insult to injury, on January 24 (Black Sunday) the waterside power station went out. Electricity was not fully restored until February 12. This is a view along First Street. (Courtesy of Ginny Keen.)

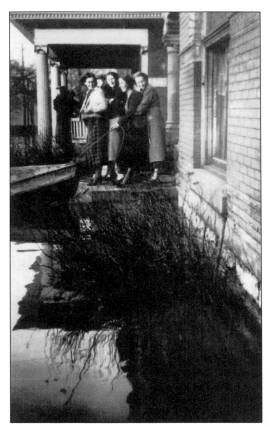

Because many of the homes of Old Louisville are built up on banks several feet above the streets, the 1937 flood turned the area into a "city of canals." Here a group of ladies, most of them still smiling, cluster on a front porch on Second Street as a boat arrives to rescue them. Sixty percent of the city was underwater. (Courtesy of Ginny Keen.)

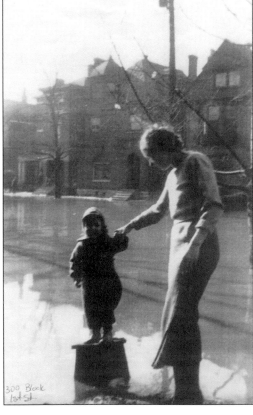

Somewhere along the 1300 block of South First Street, a touching moment is shared between a mother and her child during the 1937 flood. The child is smiling in wonder at the surrounding water while the weary mother is still trying to comprehend it. It is often children who get everyone through such times. (Courtesy of Ginny Keen.)

A rescue crew paddles up Third Street, searching house to house for anyone needing help or evacuation. The team's leader stands in the prow calling out to the houses and watching for any signs that they might be needed. From time to time, bands of fog would mist up from the water, giving the scene a surreal quality. (Courtesy of Ginny Keen.)

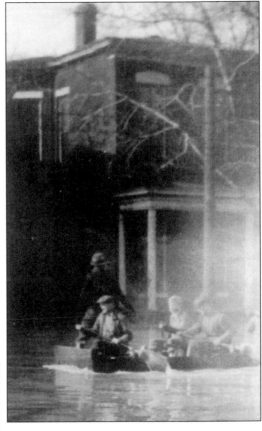

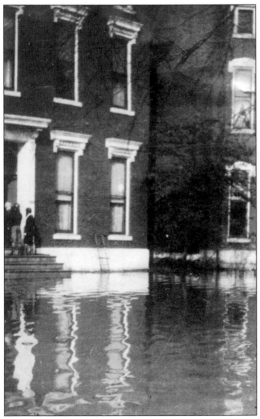

Two young men from the neighborhood, their pants rolled up to their knees, stop by to check on their elderly neighbor, Mrs. Vincenza Perrone. Ironically, The American Red Cross, so pivotal in aiding victims of the 1937 flood, was responsible for having Mrs. Perrone's house torn down - not from flood damage, but because their Louisville headquarters was directly behind Mrs. Perrone's house (on Third Street) In 1954 they acquired the property and tore it down to put in a parking lot. (Courtesy of Ginny Keen.)

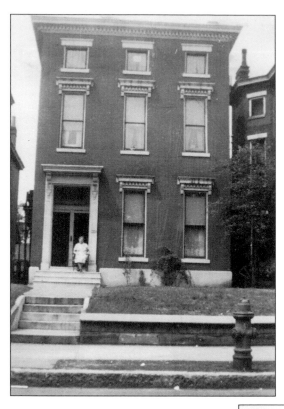

Vincenza Perrone sits on her porch in happier days watching the world go by. She was very proud of her home and the well tended garden behind it that included fig and cherry trees, roses, and all manner of flowers. This picture is believed to have been taken the year before the flood in 1936. When the river finally crested on January 27, 1937, it was at an all time high: 57.15 feet. Rainfall for that January totaled 19.17 inches, the most ever in a single month. (Courtesy of Ginny Keen.)

During the early morning hours of April 18, 2008, a 5.4 earthquake with its epicenter in southern Illinois rattled the sleeping residents of Old Louisville. Although solid construction prevented extensive damage in the neighborhood, a scene at the corner of Fourth Street and Park Avenue reminded people of the region's potential for seismic activity: an ornate chimney at the Russell Houston mansion, today's Inn at the Park, was toppled. Kentucky is one of seven states threatened by quakes along the New Madrid Fault Line. (David Dominé Collection.)

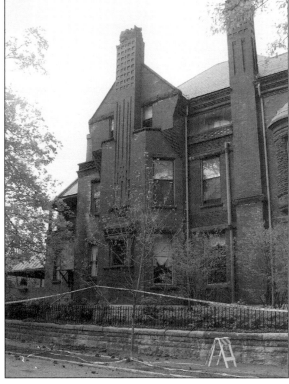

Ten

MODERN NEEDS AND CHANGING TIMES

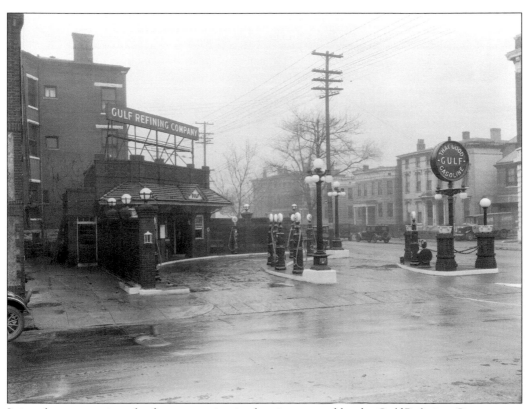

It is only a gas station: the first gas station in the city, opened by the Gulf Refining Company at the corner of Third and Kentucky, but it signaled a change in Old Louisville. With the advent of the automobile, closeness to downtown was no longer a factor for Louisville's wealthy merchant class. A departure to the suburbs began, fueled by the possibilities of more land, building a new, modern house exactly to one's own specifications and working just a short drive away. (Courtesy of University of Louisville Photographic Archives.)

A rare interior shot of Nufer's grocery at 625 Magnolia Avenue. At the time, Nufer's was one of the closest groceries to St. James Court and did a booming, upscale business. Out of 13 men in the photograph, only one is without a tie. The building stands today complete with its "Rainbow is Good Bread!" screen door. (Courtesy of University of Louisville Photographic Archives.)

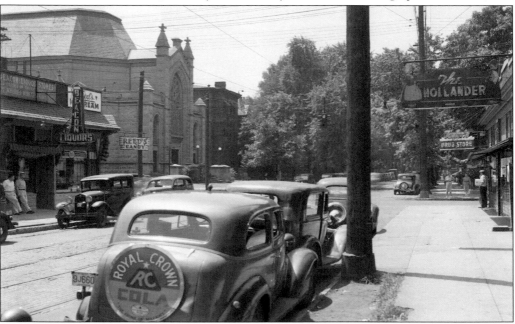

There was a time in Old Louisville when Oak Street was Main Street. This 1937 shot of the corner of Fourth and Oak Streets reveals a hub of commerce: a Rexall Drugstore, the Hollander, Reeds Candy, and Beacon Liquors share the crossroads with the Fourth Avenue Baptist Church (now the Louisville Church of Christ). (Courtesy of University of Louisville Photographic Archives.)

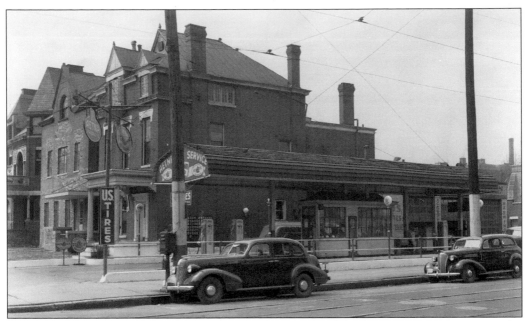

In this 1937 Caufield and Shook advertising photograph of the Aetna service station on the southeast corner of Third and Oak Streets, three Victorian homes are its neighbors. The basic buildings stand today, cannibalized within one structure, the 1200 building. Note the whitewashing of the telephone poles—an attempt at beautification. (Courtesy of University of Louisville Photographic Archives.)

Faced on three sides with brick then painted white, the three original Victorian houses are all but hidden now, cannibalized into a rectangular, boxy, modern structure. The one telltale sign of Victoriana is the black tip of one mansard roof peaking up above the facade. The Aetna service station was razed in the late 1960s. (David Dominé Collection.)

The Towers Theater on Oak Street (later known as the "Knox") was Old Louisville's local movie house for many years. In this 1926 photograph, a banner over the door touts a local live act: "Earl D. Sipe, The Original Jolly Rube" and "Earl's Food Show Every Monday." Notice the half-timbering on the Towers Sweet Shop and Luncheonette next door (right). (Courtesy of University of Louisville Photographic Archives.)

The Diamond Oils Service Station on the northwest corner of Third and Hill Streets has been an Old Louisville landmark for generations. Called the Red Diamond by locals, its distinctive terracotta roof made it the first gas station in Louisville that protected the motorist and attendants from inclement weather. The structure stands today as local preservationists and residents hope for its renovation into much-needed retail space. (Courtesy of University of Louisville Photographic Archives.)

This lovely Victorian mansion, once the residence of Nathan F. Block, is gone forever. It stood on the southeast corner of Third and Oak Streets until it was torn down and replaced by a Spaulding's Laundry (now Sam Meyers). Thanks to the preservation movement, born in the 1970s, tragedies such as this rarely occur today. (Courtesy of University of Louisville Archives.)

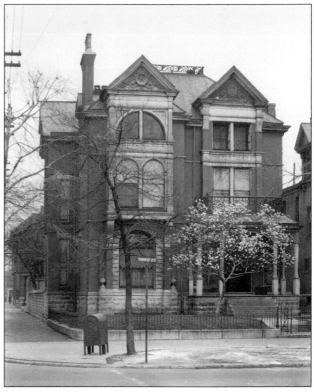

This photograph is a view of the same corner today, now the home of the Sam Meyers drive-through Dry Cleaners. Just to the east of this business is the Old Louisville Visitor's Center at 218 West Oak Street. Tourists can get information, purchase gifts, or take a historic or ghost tour of the area. They are conducted year-round. (David Dominé Collection.)

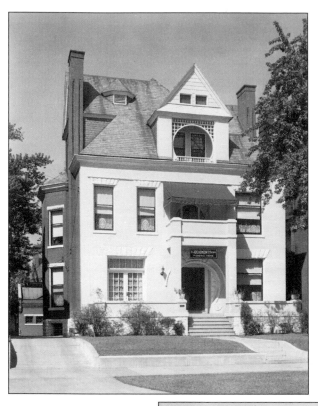

D. J. Dougherty and Son Funeral Home at 1230 South Third Street as it appeared in the 1940s. Note the unusual roofline and parallel chimneys. Originally known as Bockee Manor, the house was featured in an 1888 *Harper's* Weekly layout entitled "Louisville—City of Beautiful Homes." Today it houses the El Shaddai Christian Childcare. (Courtesy of University of Louisville Photographic Archives.)

Pictured here is yet another gas station, this one crowding the majestic lines of the Confederate monument. The monument has been controversial since its inception. At first, a woman, Enid Yandell, was chosen to design the monument. Because she was a woman, a loud outcry was made that friends of Yandell on the selection committee had not been impartial. Even though it had been a blind competition, the results were thrown out and the commission awarded to Michael Muldoon of the Muldoon Monument Company. (Courtesy of Lois Tash.)

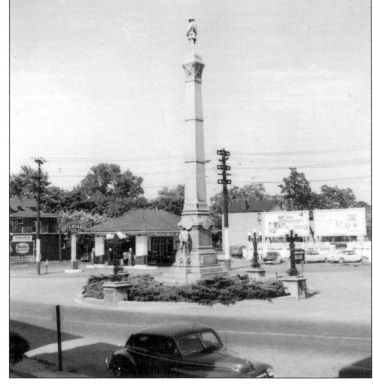

This 1940s photograph depicts Virginia McCandless posing on the base of the monument. Signage for the Standard Oil Station appears just over her left shoulder. Practically since its inception, the monument has been a traffic problem. Plans to move it to Triangle Park or dismantle it altogether have met with opposition. The last compromise was to pare the 48-foot-diameter circle of land it sits on down to an elliptical plot that interferes less with traffic. (Courtesy of Ginny Keen.)

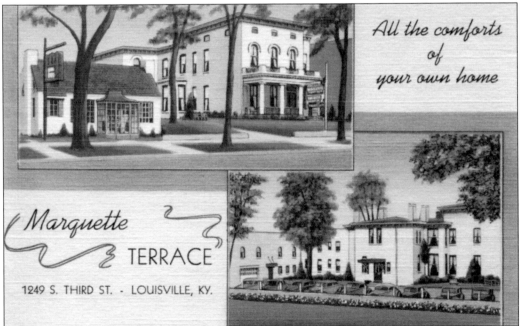

One of the best ways to reuse a Victorian mansion while still managing to retain all of its beauty and charm is to convert it into a guesthouse or bed-and-breakfast. That is precisely what the owners of the Marquette Terrace did with this Italianate mansion at 1249 South Third Street. Advertising copy on the back of this postcard reads, "A lovely place for your wife, mother, and daughter to stop while in Louisville." (Ronald Harris Collection.)

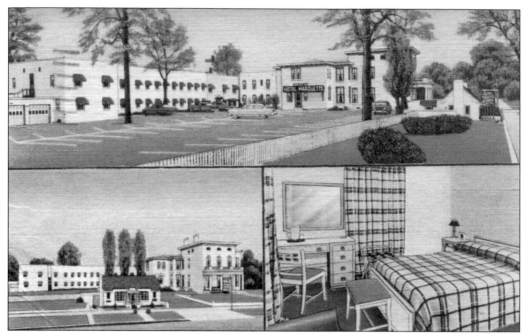

In a world full of Holiday Inns, Old Louisville innkeepers soon learned the value of advertising. The back of this Hotel Marquette Terrace postcard touts, "Inner Spring Beauty Rest for Sleep—Combination Tub and Shower Baths—Toddle House for Food—Free Parking!" Note the plaid bedspread and matching drapes: all the rage in those days. (Ronald Harris Collection.)

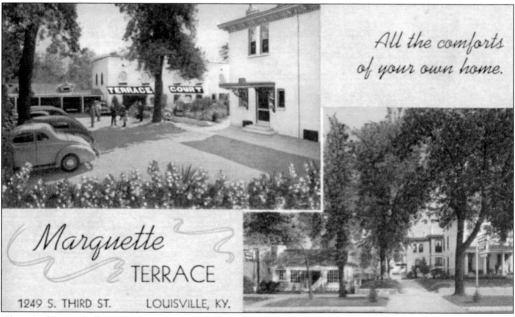

The plethora of advertising continues. Now the Marquette Terrace is billed as a "Tourists' Home-Lawn." By this time, an addition called "Terrace Court" has appeared with awnings and carport parking. The tiny cottage at the bottom of the card was the Toddle House Restaurant. Today this space is the site of Hillebrand House, a high-rise, mixed-income apartment building. (Ronald Harris Collection.)

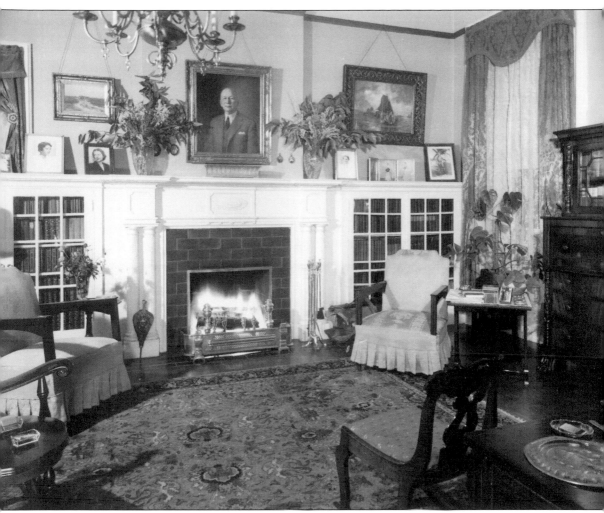

This cozy scene is a 1929 view of the library of Mr. and Mrs. J. C. Engelhard at 1348 South Third Street. Each year, they used a photograph of their home for the cover of their Christmas card. The Engelhards purchased the house in 1917, redecorating sometime in the late 1920s. Note the six-valve keys on the bottom of the chandelier. These regulated gas flow prior to the fixture's conversion to electricity. (Courtesy of the Estate of Polly and Clark Wood.)

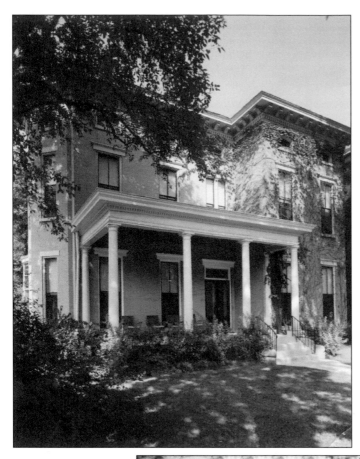

An exterior view of 1348 South Third Street showing the facade consisting of five bays; the three left bays are recessed and sheltered by a one-story classical porch. The house was built in 1870 by John J. Cooke, a Presbyterian minister. Jennie Benedict, Louisville restaurateur and caterer (and the creator of the cucumber spread Benedictine) lived here in 1887, probably as a tenant. (Courtesy of the Estate of Polly and Clark Wood.)

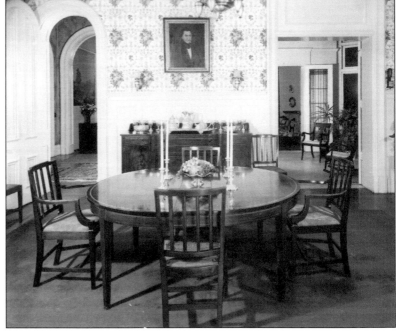

This is a 1929 shot of the dining room of 1348 South Third Street taken shortly after the home's refurbishing. After an extensive redecorating job of this nature, it was often the practice to commission a series of photographs to commemorate the occasion. A notation on an old fuse box labeled this room the "back library." (Courtesy of the Estate of Polly and Clark Wood.)

The solarium of 1348 South Third Street was added to the structure in the late 1910s, probably by Mr. and Mrs. Engelhard. There is no basement under this room and the thickness of the doorways is the same as that of the exterior walls. Plants were of particular interest to Mr. Engelhard; he was the manager of the Louisville Leaf Department of the American Tobacco Company. (Courtesy of the Estate of Polly and Clark Wood.)

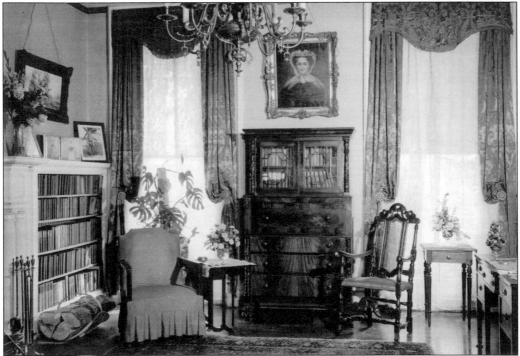

A slightly later view of the library at 1348 South Third Street with a curious difference: note that the multipaned glass doors of the bookcase are now gone! All the furnishings in the room remain the same. Only the accessories on the table and the mantel flowers are different. In later years, there were no doors on the bookcases, but when and why did it happen? (Courtesy of the Estate of Polly and Clark Wood.)

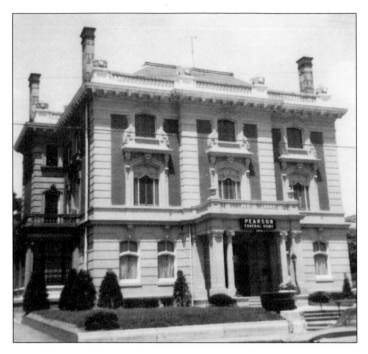

In 1924, the undertaking firm of L. D. Pearson and Son purchased one of Louisville's most beautiful residences, the Beaux-Arts Ferguson mansion at 1310 South Third Street, to serve as a funeral home. The house was originally built for Edwin H. Ferguson, owner of the Kentucky Oil Refinery. The undertaking business flourished here, and by 1951, a second mortuary had opened at 149 Breckinridge Lane in St. Matthews. This location closed in 1977 and became the home of the Filson Historical Society. (Courtesy of Pearson's Funeral Home.)

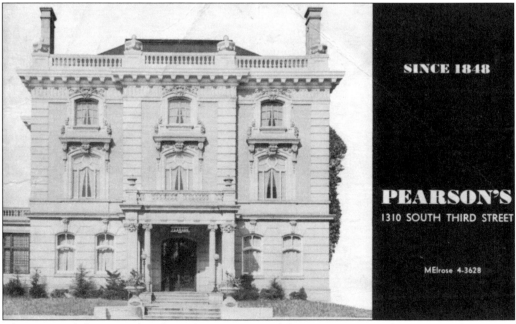

SINCE 1848

PEARSON'S
1310 SOUTH THIRD STREET

MElrose 4-3628

The cover of this 1948 brochure for Pearson's celebrates 100 years of service to the city of Louisville. L. D. Pearson started out as a master cabinetmaker. Over time, he made more coffins than anything else, so he decided to go into the undertaking business with a partner. By 1848, he and his son were the sole owners and the business was renamed L. D. Pearson and Son. (Courtesy of Pearson's Funeral Home)

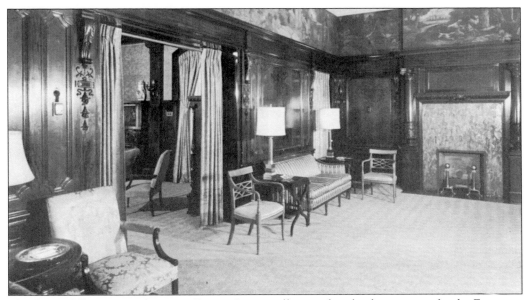

This beautifully appointed room at Pearson's originally served as the dining room for the Ferguson household. A mansion of this size was ideal for an undertaking firm. This room alone could accommodate 200 people for a funeral service. Note the large, beautifully ornate mural just below the ceiling. (Courtesy of Pearson's Funeral Home.)

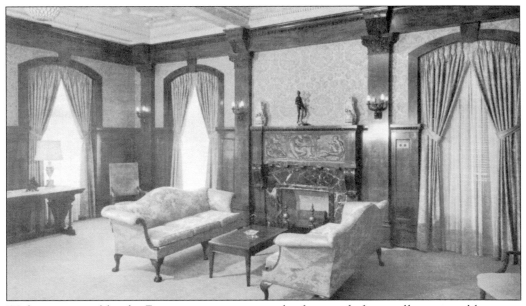

With a mansion like the Ferguson, it was not much of a stretch from well-appointed home to well-appointed funeral home. To quote the Pearson brochure: "Retaining a definite homelike atmosphere, this handsome library lends itself ideally to deft transition into a perfect setting for services with the addition of seating facilities." (Courtesy of Pearson's Funeral Home.)

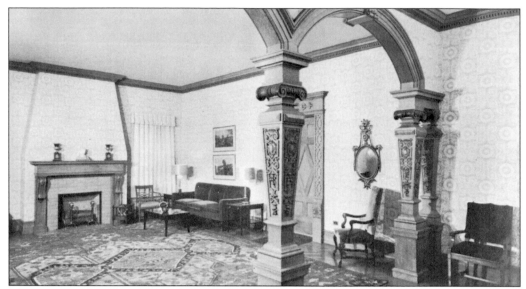

This room on the second floor of Pearson's had just been opened to the public in 1948. It features a fireplace, beautifully hand-wrought oaken arches, and an ornate Persian carpet. This room served as one of several bedrooms on the second floor when the Ferguson family lived here. (Courtesy of Pearson's Funeral Home.)

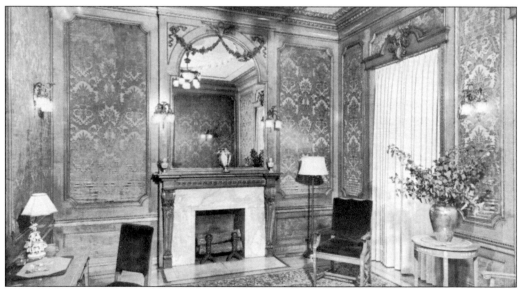

This room was utilized during busy times when a number of services happened at once. As stated in the brochure: "Ideal as a reposing room when several families are utilizing the premises, this well-appointed room supplies the need for quiet and privacy in restful and comfortable surroundings." (Courtesy of Pearson's Funeral Home.)

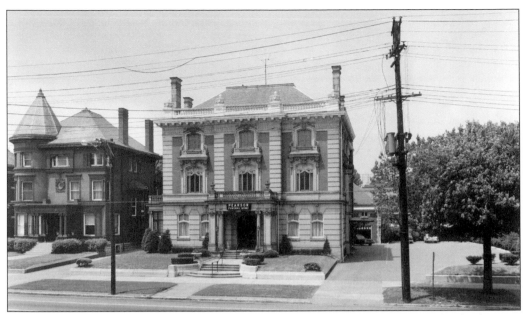

In this rare photograph, the house to the left of Pearson's Funeral Home, 1314 South Third Street, still stands. From 1938 on, the city directory listed as residents of the house, W. Edward Pearson, Clyde A. Pearson, and Paul S. Pearson, an artist. Since parking for the business consisted of only one small lot on the north side of the building, it was decided to tear the house down to create a second lot for Pearson's customers in the early 1960s. (Courtesy of Pearson's Funeral Home.)

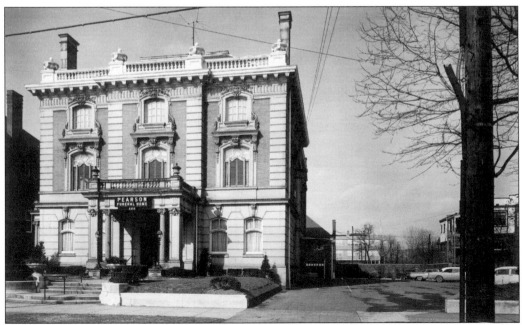

A late-1950s photograph of the Pearson Funeral Home shows the single parking lot on the north side of the building. Judging from the size of the lot, if more than two families were having funerals one can only imagine the parking problem. Note the carriage house in the rear, now the museum for the Filson Historical Society. (Courtesy of Pearson's Funeral Home.)

In 1948, a group from the Cincinnati Bible Seminary established the Louisville Bible College. From 1948 until 1990, it was located in one of Old Louisville's loveliest mansions at 1707 South Third Street. The house had been built at the turn of the 20th century by C. Robert Mengel, a prominent lumber merchant known as the Mahogany King. Since 1994, it has been the home of the Columbine Bed and Breakfast. (Courtesy of the Louisville Bible College Archive.)

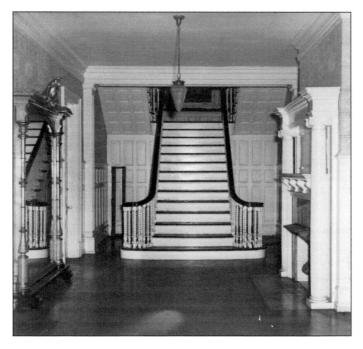

This is a view of the front entry hall of the Louisville Bible College. Even though Mr. Mengel, the Mahogany King, built his home with a variety of fine woods including Honduran mahogany, black walnut, and quartersawn tiger oak, everything had a nice, fresh coat of white paint by the time this picture was taken. This happened a lot in Old Louisville starting in the 1920s in an attempt to modernize. Today the beauty of such rare woods is properly appreciated. (Courtesy of the Louisville Bible College Archive.)

Here is a view of the same area today, magnificently restored to its original glory as the Columbine Bed and Breakfast. A vast majority of the fine hardwoods used in the mansions of old Louisville consists of old-growth timber—wood from huge, 100-year-old or older trees that are dense, many ringed, and beautifully grained. Such old-growth timber is at a premium today. (Courtesy of Robert Goldstein and Richard May.)

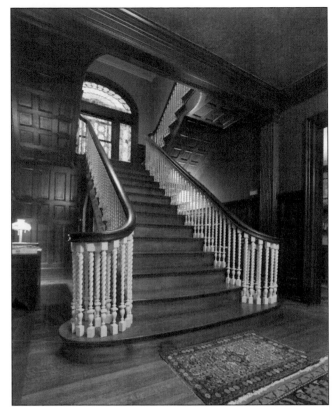

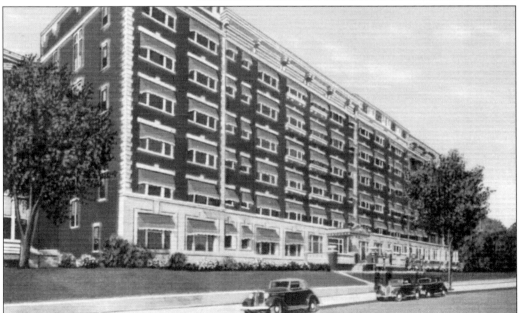

In 1917, the Puritan Apartment Hotel opened at the corner of Fourth and Ormsby Streets. It was billed as "the South's most exclusive apartment hotel." Perhaps it was a bit too exclusive. It was restricted, and Jews were not allowed to live there. In answer to this outrage, Jews built the Cavalier Apartments directly across the street. (Ronald Harris Collection.)

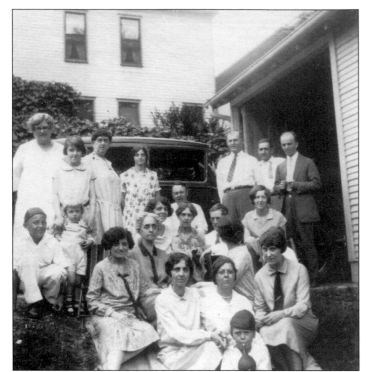

In the 1920s and 1930s, Old Louisville became a home for large, extended families. As the wealthy made their move to Cherokee Triangle and beyond, the middle class discovered the genteel, spacious residences of Old Louisville. Here members of the Laufer, Money, Wren, Beaven, and Brady families pose for a picture in the backyard of 1132 South First Street. (Courtesy of Norma and Bob Laufer.)

Brown McCandless jokes with his future sister-in-law, Marine (pronounce May-reen) Boston Van Zant. His future wife, Virginia Boston, is taking the picture. They pose in the front yard of 1619 South Third Street. The building behind them with the triple porches is 1616 South Third Street. (Courtesy of Ginny Keen.)

Virginia Boston takes her turn in front of the lens. Brown McCandless and Virginia Boston were still courting when this picture was taken. A year later, she would become Mrs. Virginia McCandless. It was 1945, World War II, and Brown McCandless was a dashing marine who would become her husband. She had never met anyone who had the first name of Brown before. (Courtesy of Ginny Keen.)

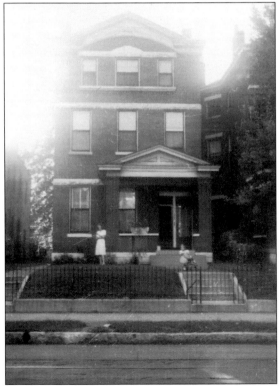

Virginia Boston McCandless is pictured here in the front yard of 1360 South Second Street. This picture was taken around 1950. It is a late summer day, and the sun is setting behind the house. Her baby daughter Linda plays with a tricycle on the walkway. Virginia McCandless is a longtime resident of Second Street and has lived in the Old Louisville neighborhood since 1944. (Courtesy of Ginny Keen.)

Although the snow is beautiful and the little girl (Linda McCandless) in the white scarf and her mother's coat adorable, the house on the other side of the hedge is of particular interest here. It is 1362 South Second Street, the site of a parking lot today. (Courtesy of Ginny Keen.)

In the seminal stages of laying out property for building lots in Louisville, it is said that one of the city fathers insisted that the lots be of a certain size. He wanted to assure that, unlike a lot of other cities such as Boston and New York, every home, "rich man's castle or poor man's cottage," would have a spacious backyard. Pictured here, Ginny (left) and Linda McCandless pose for the camera in the backyard of 1331 South Second Street. (Courtesy of Ginny Keen.)

Lois Ball and a friend (Lois is on the right) play on the slide in Triangle Park on Confederate Place. Many families bought houses here for the adjacent park, pool, and playground. As the Ball sisters grew up, their neighborhood would come down around them, a victim of urban renewal—and the University of Louisville's need for expansion. (Courtesy of Lois Ball Tash.)

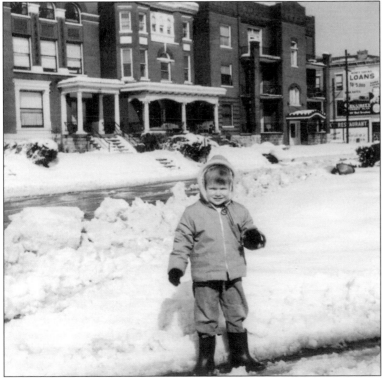

Lois's little sister Janene Ball plays in the snow in front of 2014, 2012, and 2010 Confederate Place. All of the buildings pictured behind her are now gone. Note the Victorian apartment building with six sleeping porches and a suspended canopy over the door. In her lifetime, Lois Ball Tash has seen two family homes and an apartment building she lived in torn down. (Courtesy of Lois Ball Tash.)

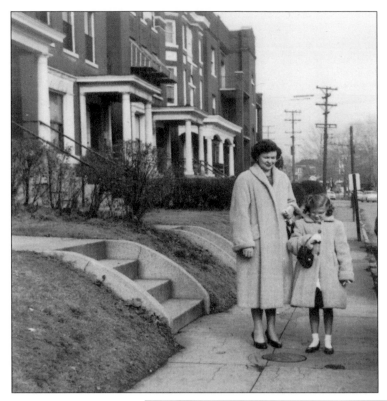

In matching alpaca coats, Lois Ball and her mother Evelyn, stand in front of their home at 2016 Confederate Place (razed 1966). At one time many of the homes on Confederate Place had dark blue or green canvas awnings on the windows. (Note the striped awnings on the second floor windows above the third porch.) This area is presently the location of a new high-rise dormitory for the University of Louisville campus. (Courtesy of Lois Ball Tash.)

Lois Ball and her father, Robert, pose for an Easter Sunday photograph beside the family's 1956 Chevy convertible. At this time, the Confederate monument behind them still had its four triple-globed wrought-iron lampposts in place. They were removed sometime in the 1960s when the monument was reconfigured for traffic flow. (Courtesy of Lois Ball Tash.)

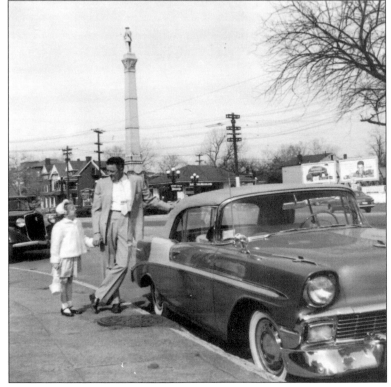

All that remains of 2014 Confederate Place is the foundation in this photograph taken at the time of the row's razing in the mid-1960s. The shell of 2012 is still standing, most of its windows either removed or broken. Robert Ball, Lois's father, took this picture, and then crossed the street to get a better shot of 2012 Confederate Place, or what was left of it. (Courtesy of Lois Ball Tash.)

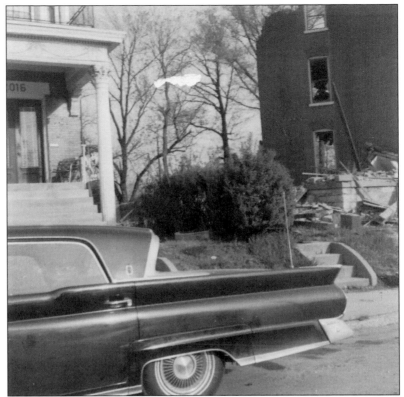

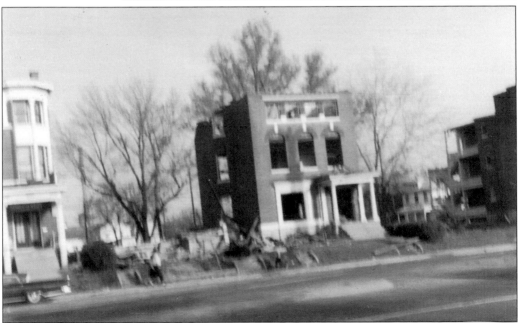

Here is Robert Ball's wider, rather shaky shot of the disappearing row of houses: the foundation of 2014, the shell of 2012, and another vacant lot where 2010 Confederate Place used to be. Little by little, the neighborhood was vanishing. It is now gone. Lois Tash can never go home again. (Courtesy of Lois Ball Tash.)

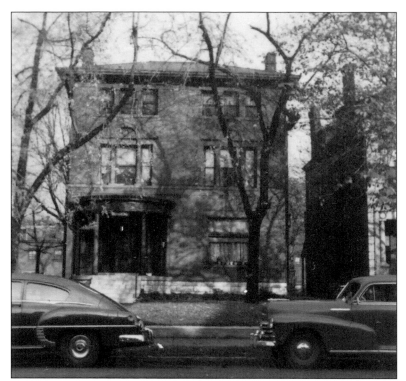

Lois Ball's father, Robert, and his mother, Estelle Owings Ball, owned this house at 1133 Garvin Place. There they ran a retirement home for ladies called the Tranquil Inn. It was indeed a tranquil place where each resident was allowed to do whatever he or she pleased. One day, the Balls got an offer that was hard to pass up: Winn Dixie wanted to buy the house and tear it down to build a supermarket. (Courtesy of Lois Ball Tash.)

Here is a closer shot of the colonnaded semicircular front porch of the Tranquil Inn retirement home for ladies at 1133 Garvin Place. Residents there were allowed to sew, play games, and generally do what they wanted when they wanted. It was a fine place to live. But Winn Dixie needed the space to build a supermarket. Today the backside of an abandoned Winn Dixie sits on this spot. (Courtesy of Lois Ball Tash.)

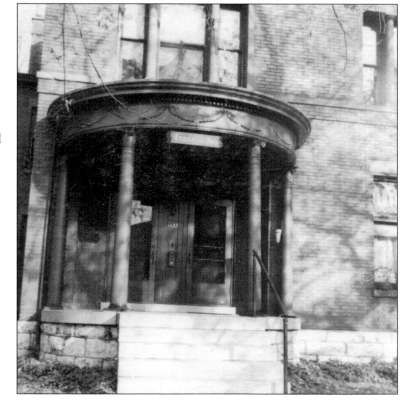

Today magnificent renovations like this one at the Columbine Bed and Breakfast pepper the Old Louisville landscape with hope. Lovers of fine Victorian homes have rediscovered America's largest neighborhood of such houses and have begun to relocate here from places like San Francisco, Boston, and New York City. The old-growth Honduran mahogany in these homes alone, a species now extinct, is priceless. (Courtesy of Robert Goldstein and Richard May.)

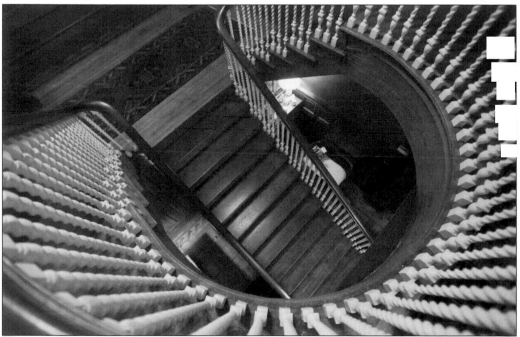

Much like the view from the top of this winding staircase in the Columbine Bed and Breakfast, the history of Old Louisville is a winding one. From millionaires and magnates to wartime workers and college students—from mansions to boardinghouses then back again to mansions—from urban renewal and the need for parking lots, to historic preservation, Old Louisville's timeless beauty survives. (Courtesy of Robert Goldstein and Richard May.)

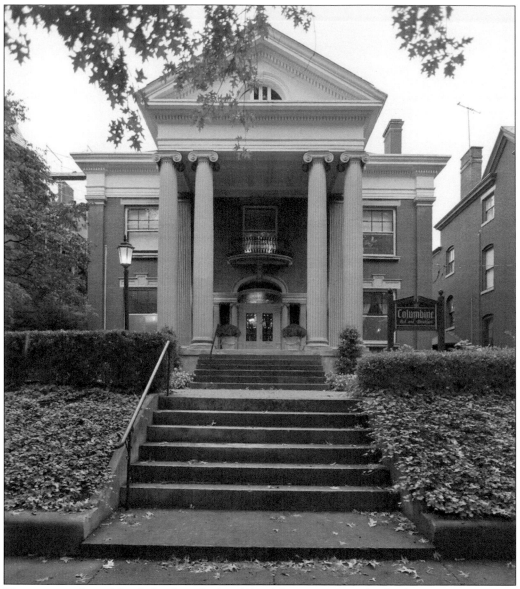

This exterior shot of the Columbine Bed and Breakfast at 1707 South Third Street gives a whole new meaning to the phrase curb appeal: it is only 1 of over 1,000 Victorian structures in Old Louisville. Mansion after mansion lines the streets with the grace and majesty of a bygone time. Architecture of this magnitude must be protected and cherished—for its equal will never be seen again. (Courtesy of Robert Goldstein and Richard May.)

THE VISITORS CENTER IN HISTORIC OLD LOUISVILLE

Located at 218 West Oak Street, the Visitors Center in Historic Old Louisville is open Monday through Saturday from 9:00 a.m. to 4:00 p.m. to assist you in experiencing the rich cultural heritage of Louisville. Whether you are looking to view the elegant architecture of Victorian mansions in the Old Louisville neighborhood or to experience the flavor and culture that the community offers, it is a must on your visit to Louisville, the 16th largest city in the United States. Old Louisville is a National Preservation District with grand homes and architectural styles of centuries past laid out along miles of tree-lined streets and boulevards. With some 1,400 historic structures spread out over more than 45 square blocks immediately to the south of downtown Louisville, Old Louisville is a virtual open-air museum and popular destination for old-home aficionados in the region. In addition to providing you with information about local restaurants and bed-and-breakfast inns, friendly volunteers at the Visitors Center in Historic Old Louisville are available to help you discover the neighborhood with a variety of popular tours and walks. Here you can pick up a self-guided brochure that will show you the highlights of the neighborhood on your own, or else you can book a chauffeured history and architectural tour or organize an evening lantern walk designed to tout the haunted past of this grand Victorian neighborhood. For more information, contact:

The Visitors Center in Historic Old Louisville
218 West Oak Street
Louisville, Kentucky 40203
(502) 637-2922
www.historicoldlouisville.com

Discover Thousands of Local History Books Featuring Millions of Vintage Images

Arcadia Publishing, the leading local history publisher in the United States, is committed to making history accessible and meaningful through publishing books that celebrate and preserve the heritage of America's people and places.

Find more books like this at
www.arcadiapublishing.com

Search for your hometown history, your old stomping grounds, and even your favorite sports team.

Consistent with our mission to preserve history on a local level, this book was printed in South Carolina on American-made paper and manufactured entirely in the United States. Products carrying the accredited Forest Stewardship Council (FSC) label are printed on 100 percent FSC-certified paper.

MADE IN THE USA